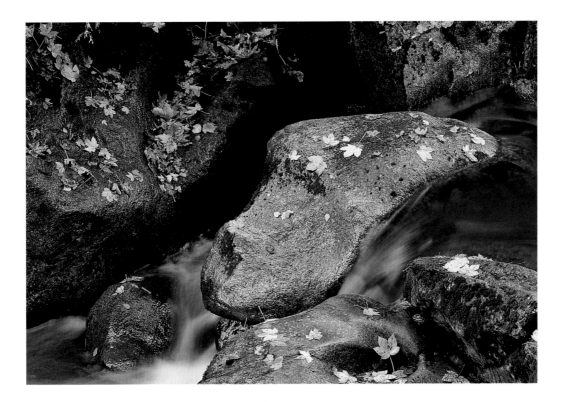

Journey through

LOWER BAVARIA

Photos by

Martin Siepmann

Text by

Trudie Trox

Stürtz

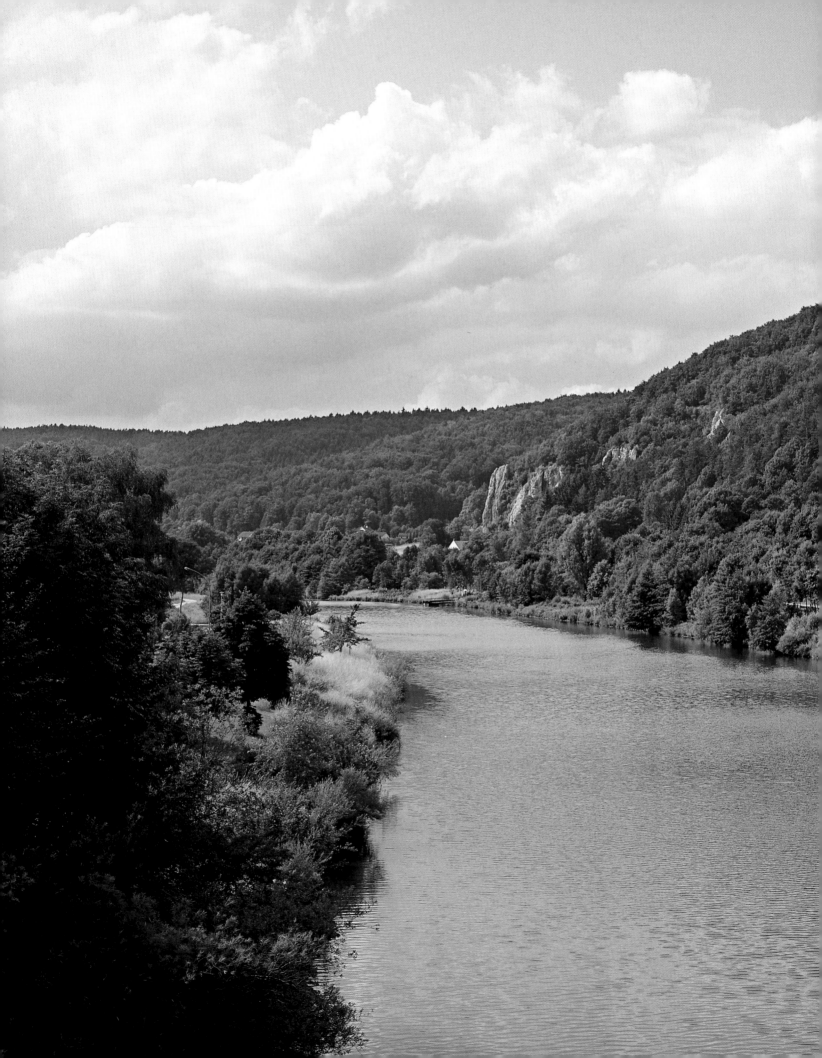

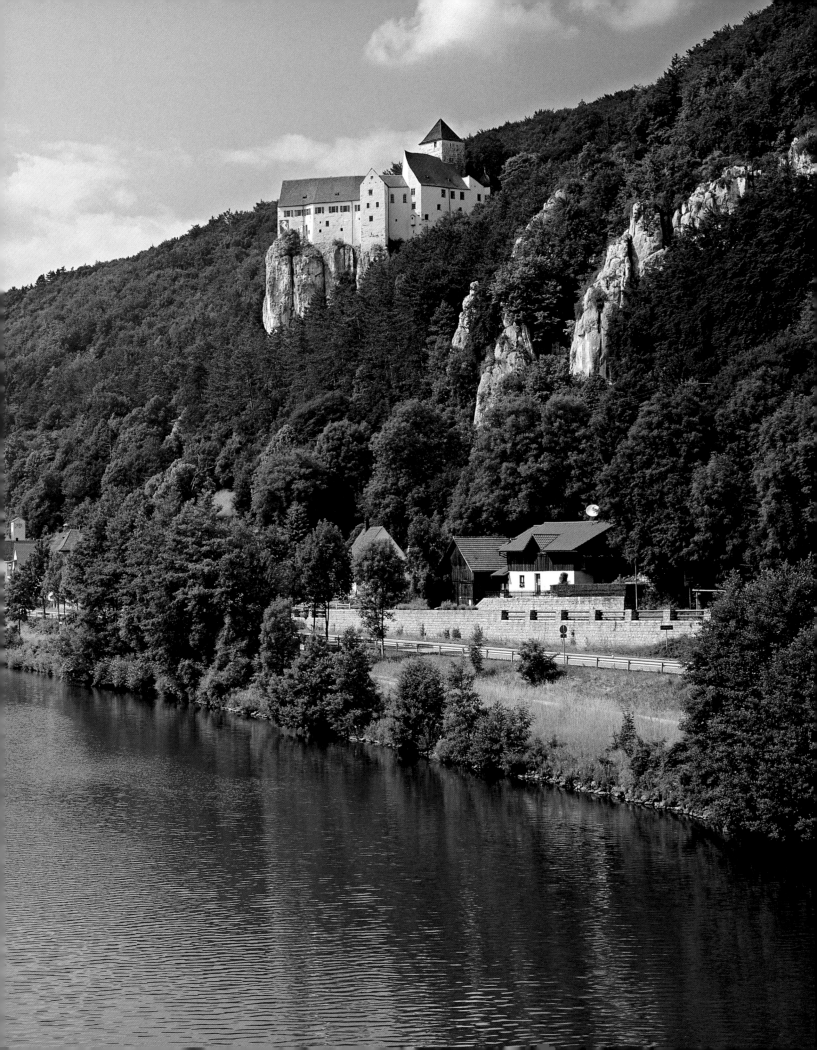

INHALT

First page:
*Babbling brook in the
ravine of the Buchberger
Leite near Freyung,
one of the hundred best
beauty spots in Bavaria.*

Previous page:
*Schloss Prunn clings to
a rocky precipice high up
above the Main-Danube
Canal near Riedenburg.
The castle was first
mentioned in 1037.*

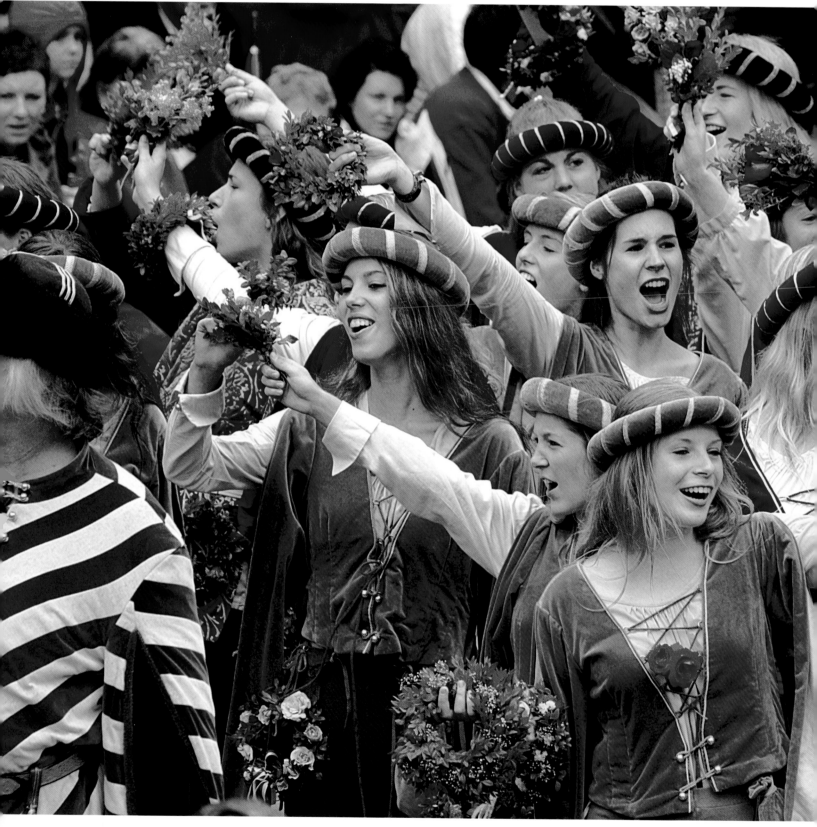

Below:
Every four years the people of Landshut get dolled up in historic costume for the Landshut Wedding celebrations *which commemorate the spectacular marriage of ducal son and heir Georg to Polish princess Jadwiga in 1475.*

Page 10/11:
In Obernzell on the Danube the influential bishops of Passau created an idyllic summer residence for themselves and *their entourage. The restored palace of these once mighty rulers now houses a museum of ceramics.*

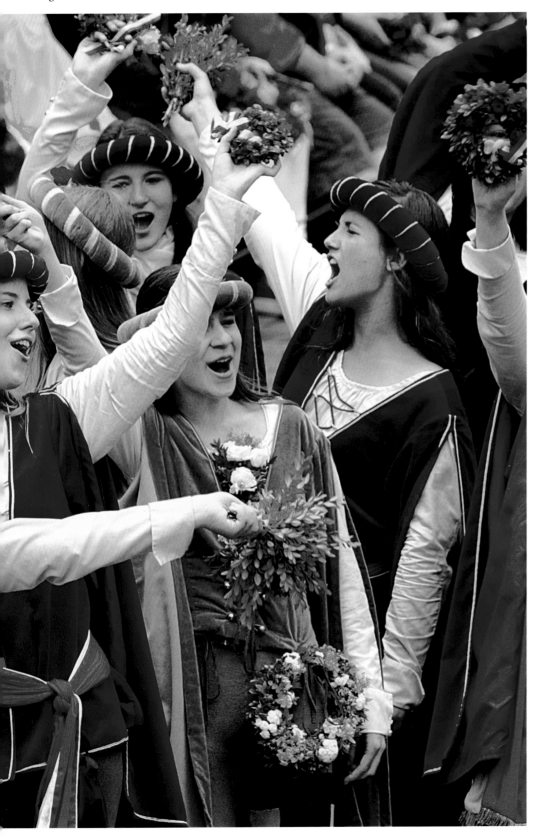

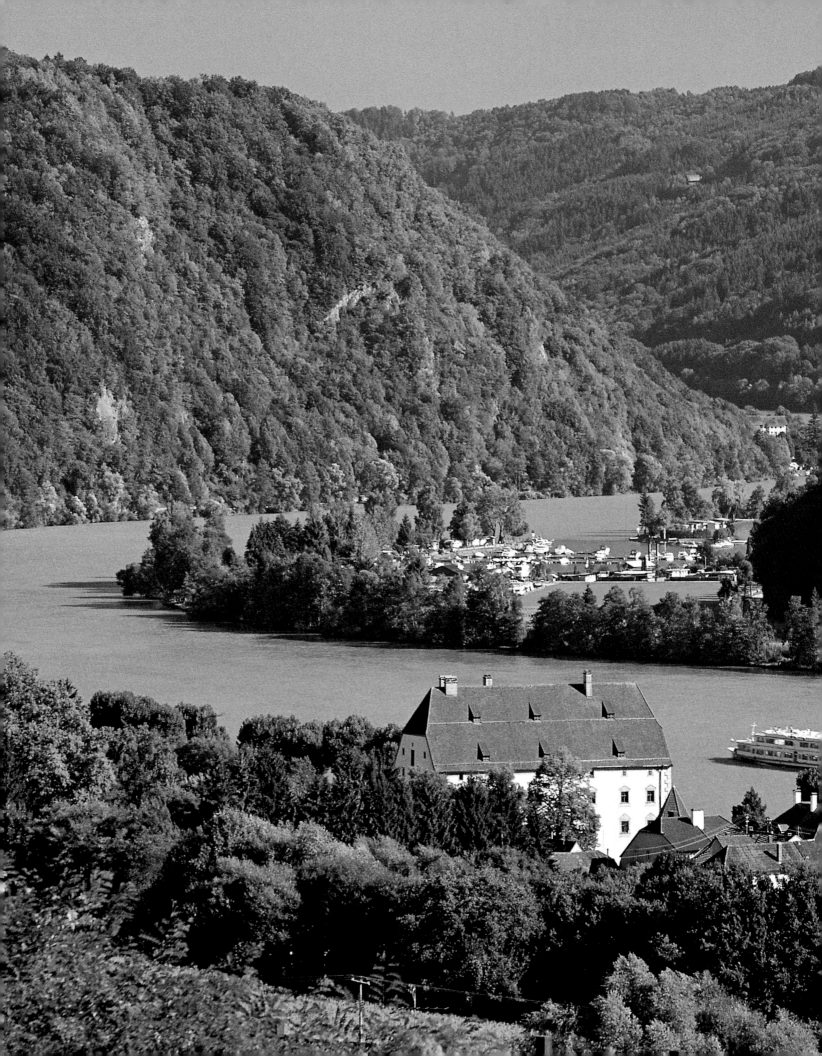

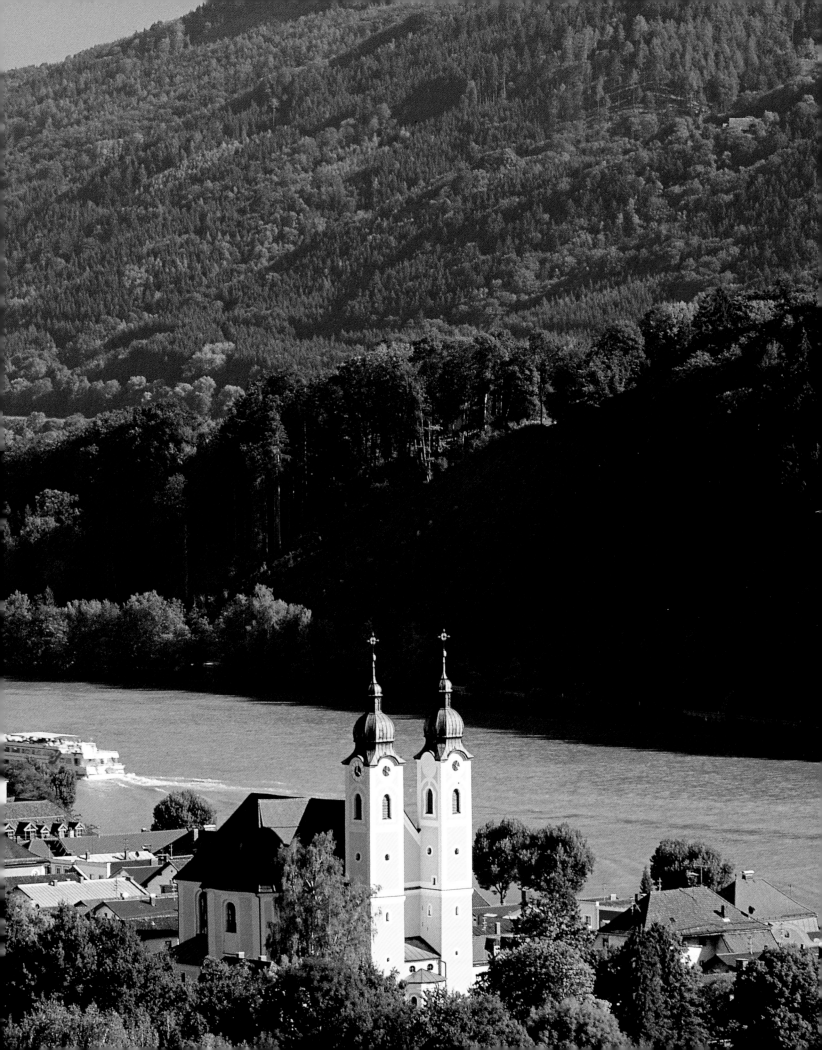

LOWER BAVARIA –

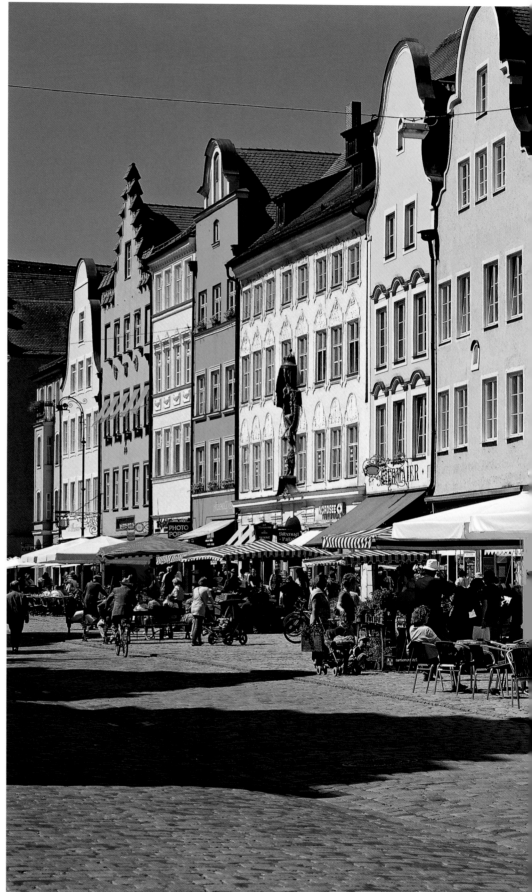

Once a major centre of trade for the Bavarian duchies and their neighbours, Old Landshut's main street is now a charming open-air forum for both business and pleasure. On Saturdays a bustling market fills the streets and in fine weather the pavement cafés are humming with custom.

If in the Bavarian capital of Munich you ask just where or what Lower Bavaria is, you're likely to get a somewhat indistinct reply. Or even a rather embarrassed one. Your opposite number may utter the words "Bayerischer Wald" and "Arber" – familiar to most thanks to the ski world cup. People will also have heard of Passau with its three rivers – due to the not infrequent flooding and the political japes on Ash Wednesday which have also made Vilshofen popular. Dingolfing is famous for its BMW factory – and Deggendorf also rings a vague bell. After all, it's signposted often enough as the end of the A92 motorway which zooms past Munich Airport.

Every four years Landshut celebrates a famous historic festival – but does your average *Münchner* know that it's the capital of Lower Bavaria? Probably not. When the people of Munich ferry their guests around, they tend to take them to Garmisch-Partenkirchen rather than Landshut. The charming royal seat of the influential Wittelsbach dukes is such a long way away from Munich, they cry – yet Freising (another favourite) is only half the distance and still in Upper Bavaria. Or is it? Then the guesswork starts; where are the regional boundaries exactly? Who actually knows that the 10,330 square kilometres (3,988 square miles) of Lower Bavaria stretch from the hop fields of the Hallertau to the serene valley of the Altmühl and the district of Kelheim? If South Bavarians have trouble with their local geography, non-Bavarians – let alone non-Germans – don't stand much of a chance at all ...

To confuse matters, some bright spark on the Bavarian tourist board has conveniently lumped the administrative districts of Lower Bavaria (Niederbayern) and Upper Palatinate (Oberpfalz) together and christened it "East Bavaria". To be fair, the Danube does link the two together. The Upper Palatinate and Bavarian forests also have much in common regarding their geological history and geography. Popular theme routes such as the Straße des Porzellans (Porcelain Route) and the Glasstraße (Glass Route) and also the

THE HISTORIC HEART OF OLD BAVARIA

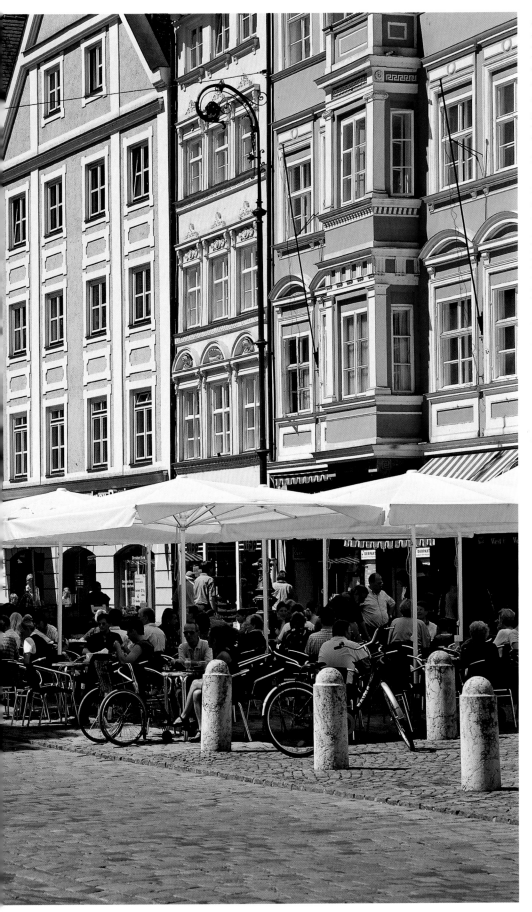

cycle tracks along the rivers zigzag through the region like leitmotifs. Whether you call it East Bavaria or not, there's plenty to see and do here. So many holidaymakers fail to appreciate the exotic qualities right on their doorstep when they fly off to far-away places. Why go parrot spotting in the jungle when trying to catch sight of the black woodpecker or bluethroat in the Bayerischer Wald or Bavarian Forest can be just as exciting?

In both Lower Bavaria and Upper Palatinate the presence of the Iron Curtain slowed development in the area bordering on the Czech Republic. Despite providing a valuable source of energy for the manufacture of porcelain and glass for many centuries, the people here were and remained poor. By way of contrast, in Passau the prince-bishops lived like kings off the fat profits of their many lands and estates, frequently waging war against their worldly adversaries in Landshut and Munich.

MILLIONS OF YEARS OF GEOLOGICAL HISTORY

Chronicler Johannes Thurmair from Abensberg, also known as Aventinus (1477–1534), published the first map of Bavaria in Landshut in 1523, in which the names Upper and Lower Bavaria and the Bavarian Forest were used. Up into the 19th century the latter was also the general term for the Bavarian Forest which peaked at the Großer Arber, 1,456 meters (4,777 feet) above sea level. The crystalline rock of the Bohemian Mass, as it's also called, dates back to the Palaeozoic period, making it one of the oldest mountain ranges in Germany. In the northwest it peters out into the Upper Palatinate Forest and in the southeast in the Sauwald in Austria.

300 to 400 million years of geological history have left their mark on the area: both the Tertiary period with its tropical climate and excessive weathering of the granite and the Ice Age. During the latter 125 meters (410 feet) of ice pressed down onto the Northern Forest or Nordwald, as the Bavarian and Upper Palatinate forests were called in the Middle Ages. It created cirques which filled with meltwater, resulting in lakes such as those on the Arber and Rachel. Powerful masses of water washed scree and fertile soil into the wide river valleys, with the wind which characterised the periods between the ice ages blowing fine particles across to what is now the Gäuboden and the tertiary hills north of the plain of Munich – where hops positively thrive.

The easterly valley of the Danube traces a fault along which the mountains of the Bavarian and Bohemian forests were formed. West of Regensburg in the Bavarian Jura we are suddenly faced with a geological anomaly: the rise of the Danube near Kloster Weltenburg. Strictly speaking it's not a rise at all; in the Riss glaciation the ancient Danube flowing between Dollnstein (west of Eichstätt) and Kelheim shifted its river bed south into the valleys of a number of tributaries which had carved their way 180 meters (590 feet) into the chalk cliffs at the famous strait of Weltenburg. The Danube merely forced its way through the remaining 10 meters (30 feet) to form the present gorge, its former site now occupied by the picturesque River Altmühl.

IN THE NAME OF NATURE CONSERVANCY...

... the Bavarian government turned an area of 13,000 hectares (ca. 32,000 acres) into the Bavarian Forest National Park in 1970. It was the first in Germany and is now the biggest; it grew to 24,000 hectares (59,300 acres) in 1997. The resistance of the local populace, enraged by advocates of the national park "who'd even protect the bark beetle if they could", as they scathingly declared, has since dwindled. Within the space of almost 40 years the working forest has radically changed; trees blown down by the wind or uprooted in their old age are left where they fall to form miniature biotopes for beetles, fungi, mosses and other living organisms. This process, and that of the "new" animal world of lynx, wolf, bear and bison (in huge enclosures), is excellently explained at the park visitor's centres in Neuschönau and Ludwigsthal. Man is not excluded here. On the contrary: the critics of old have discovered that tourism can prove a useful source of income.

The Bavarian Forest National Park has two smaller siblings, the Naturpark Bayerischer Wald measuring 307,700 hectares (ca. 760,300 acres) from the Danube to the Czech border, founded in 1967, and the Naturpark Oberer Bayerischer Wald to the north, covering 179,600 hectares (443,790 acres) of the Upper Palatinate districts of Cham and Schwandorf. Together with the Czech national park of Sumava the conservation areas form part of the largest area of forest in Central Europe. Theme walks and thousands of miles of hiking trails and cycle tracks lead visitors to sites of great natural interest and beauty: into the dark woods and rocky precipices of the national park, to the gushing cascades

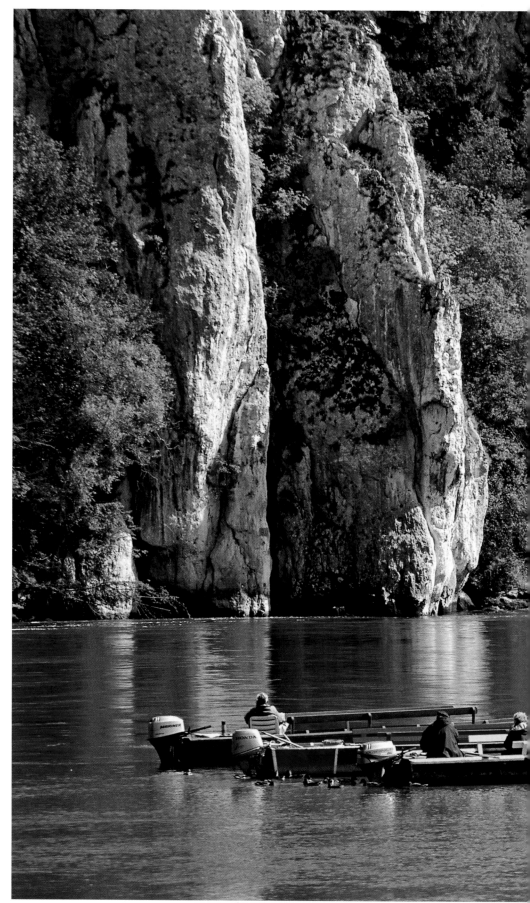

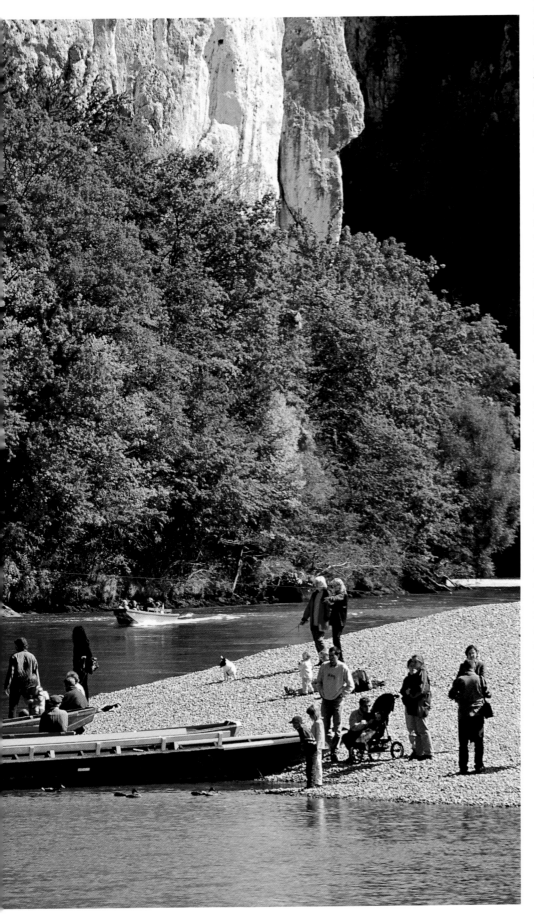

of the Rißloch waterfalls, to the wild ravines of the Buchberger Leite. In winter you can zoom down the snowy slopes of the Großer Arber or attempt the Bayerwald cross-country ski run – all 150 kilometres (93 miles) of it from Silbersbach in the Lamer Winkel to Neureiche-nau at the foot of the Dreisessel (1,312 metres/ 4,305 feet). Winter in the Bavarian Forest is guaranteed to be snowy; ski trails through glittering icy meadows and glistening fairy-tale forest make romantic dreams of a quiet and white Christmas come true.

In retrospect, straightening the River Inn at the beginning of the 20th century was not a particularly welcome ecological measure. Neither was the building of various dams in the 1940s which generated four Inn reservoirs between the mouth of the Salzach at Haiming and Neuhaus. However, since then these places have become a paradise for our feath-ered friends, with almost 250,000 waterfowl and nesting areas for 130 different species which happily breed in the ideal conditions offered here. The European reserve of the Lower or Unterer Inn – one of 27 Ramsar sites in Germany – is not only of interest to ornithologists. Botanists can also be found meandering through the meadows in search of rare orchids and other plants, around which an incredible 800 types of butterfly flit in the sunshine. Other aboriginal riverine land-scapes, complete with riverside forest and ox-bow lakes, can be found along the cycle tracks downstream from Straubing on the Danube or along the lower reaches of the River Vils.

FARM CULTURE AND MUSEUM EXHIBITS

The cultivation of the land, and particularly of the wetlands near the rivers, and their sub-sequent habitation was in many places down to the monasteries, such as Weltenburg and Niederaltaich. Old chronicles report that in the Bavarian Forest the cold was not benefi-cial to the growing of wheat and caused every fourth rye harvest to fail; the Gäuboden, how-

ever, was heralded as the granary of Bavaria. With the industrialised agricultural processes of the 21st century the Gäuboden still produces top yields; fertile loess soil and gently rolling hills provide ideal conditions. Special crops such as hops and asparagus constitute much of the farming in the northwest of Lower Bavaria where layers of loess also cover the undulations of the Hallertau, petering out into loose sandy soils further north.

What crop farming is to the Gäuboden and Hallertau, horses are to the Rottal. Horse breeding goes way back here. With its lush pastures and fertile fields the area provided a solid economic basis for the rearing of horses. As the dukes of Bavaria had promoted equestrian farming since the 16th century, ever in need of good mounts for the cavalry, local farmers who 'dabbled' in horses had a fair source of income. Landshut even had its own state stud farm from 1768 to 1980 where the breeding of Rottaler played a not unimportant role. This middle-weight draft and carriage horse has been documented since the 19th century. After the Second World War successful attempts were made to produce a more agile animal for hunting and riding.

How the farming community spent their lives, how and with what they built their houses, how they cooked, ate and slept is all recorded at a number of excellent open-air museums: the museum of rural habitation in Massing with impressive farmhouses from the Hallertau, Rottal and Isartal, the Bavarian Forest museum village near Tittling, the Lindberg farmhouse museum and the open-air museum at Finsterau. The latter two are also dedicated to the farming culture of the Bavarian Forest. The events staged at the various complexes help to make ancient crafts come alive, allowing visitors to gain first-hand experience of rural customs and traditions.

Many of these conventions are rooted in pre-Christian cults centred on fertility rights, the harvest festival or the driving out of winter. One of these is *Raunächte*, where young men roam the streets in frightening masks. *Wolfauslassen*, a ceremony observed in Rinchnach near Regen, is also rather terrifying. The harrowing noise and deafening clanging of cowbells outside the village houses dates back to an ancient farming practice in which shepherds made a great din to protect their flocks from wolves as they grazed the forest meadows. When they drove their animals back down to the barn in autumn from their summer pastures, to keep danger at bay they tied bells onto themselves to discourage attackers and 'hurried up' the cows with whips.

BACK TO THE ROOTS

Horses were greatly treasured by the Celts as mobility was crucial to their rather Nomadic existence. It's thus strange that it was the Celts who were the first to build fixed settlements similar to towns in c. 800 BC. It has been proved that Lower Bavaria – or the valley of the Altmühl, the Gäuboden and around Landshut, to be precise – is where the Celts had one of their main centres of activity. Much archaeological evidence also illustrates that long before this, in c. 5500 BC, animals were kept on the water meadows of the Danube and simple farming was carried out on the loess terraces. Many ancient exhibits are on show at modern museums, such as the museum of archaeology in Landau, at the Quintana in Künzing (between Osterhofen and Vilshofen) and in Kelheim. Unfortu-nately, in the early days of archaeological research many of the best finds which were often happened upon by chance were sent off to join the big collections in Munich.

The oldest artefacts were unearthed in caves in the ancient valley of the Danube, now the Altmühltal: the likeness of a mammoth, carved out of ivory and about 50,000 years old, and rock carvings of an ibex in a trap and a female person in the Kleine Schulerhöhle, dated to approximately 10,000 to 15,000 years before Christ. In c. 5500 BC gatherers and early crop farmers began to emerge along the banks of the Danube, characterised by the ornamenta-tion they used on their pottery, such as lines and zigzags. The houses these early settlers inhabited were of an impressive size, some being almost four meters (13 feet) long and about seven meters (23 feet) wide. The walls were made of wattle and daub and the steep roofs decked with reed or straw.

The turn of the second millennium BC heralded the dawn of the Bronze Age; neck rings, daggers, ornamental pins and broaches were placed in graves to accompany the dead on their journey over to the other side. Evi-dence of large wooden pillared buildings, similar to timber-framed houses, has been found for this period. Bronze could be put to many uses and greatly encouraged trade. Finds of bog iron ore in the Gäuboden and new skills in the processing and working of metal promoted the production of iron

17

The rural reaches of Rottal were catapulted into the top ten of international spas in the 1970s when hot springs were discovered here.

State-of-the art cures can now be had in the three health resorts of Bad Füssing, Bad Birnbach and Bad Griesbach (shown here).

swords, yokes and other metal parts for horses and carts. The Celts have been recognised as the early masters of ironwork. In c. 450 BC Greek historian Herodotus tells of a tribe whose upper classes had active contact to the Mediterranean, from whence they imported gold and other goods. This was used to make coins, found fairly recently in their hundreds in a garden near Wallersdorf northeast of Landau. This newly minted "crock of gold" as it became known – after the saying that there's a fortune to be had at the end of the rainbow – was probably hidden from marauding Germanic tribesmen here thousands of years ago where it remained safely secreted until the 1980s.

LIFE ON THE LIMES

Life for the *milites*, the Roman soldiers posted to the various forts along the Roman frontier, was definitely not rewarded with pots of gold. Together with Regensburg or Castra Regina Passau was one of the main centres on the "wet limes", where the Danube formed a natural boundary to the province of Rhaetia founded in 15 BC. Today the modern Roman museum of Kastell Boiotro stands proud atop the foundations of an ancient Roman fort. The fertile soil of the Gäuboden provided plenty of food for the Roman garrisons and suitable supplies for the Baiuvarii or people from Bohemia who infiltrated the area from the east from c. 400 AD onwards. Thuringians, Langobards and Franks also settled in the Danube region in what is now Lower Bavaria. Slavic Wends, who were forced to set up home in the Hallertau in c. 800, have also left their mark in the many place names containing the word *Winden*.

THE GLORIOUS NOBLES OF BAVARIA: THE MIDDLE AGES AND THE RENAISSANCE

Religious guidance was provided by Benedictine monks in the duchy of the Agilolfinger who ruled Bavaria until 788 – when it became part of the Frankish Kingdom. The region took on a new identity when in 1180 Emperor Friedrich Barbarossa gave the duchy

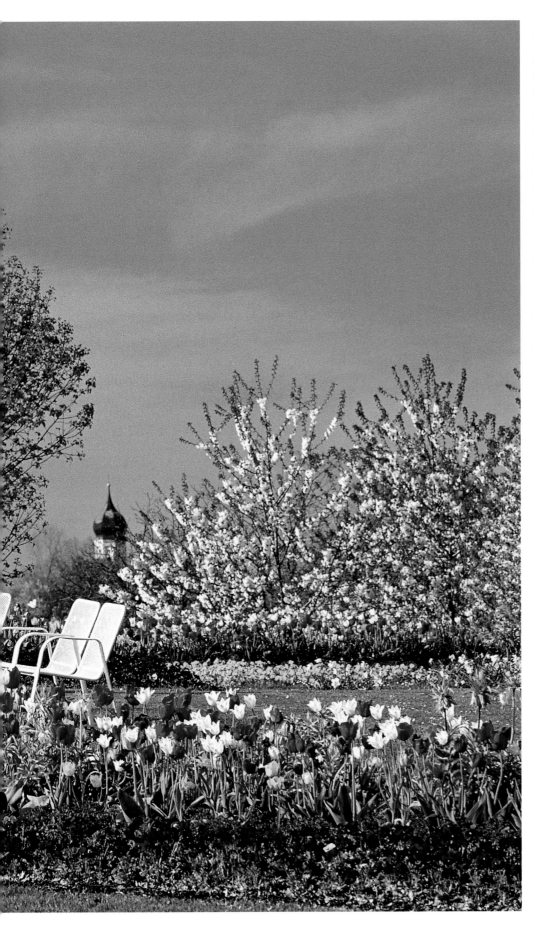

of Bavaria to Wittelsbach potentate Otto I. His son Ludwig of Kelheim (1173–1231) pursued a vigorous territorial policy and managed to claim inheritance to the duchy and electorate over the Palatinate, instantly catapulting him to the position of representative to the king. This honour permitted him to bear the lion on his coat of arms; the blue-and-white diamond pattern so readily associated with Bavaria was added by Ludwig's wife Ludmilla, one of the dynasty of the counts of Bogen. Ludwig was responsible for the founding of the cities of Landshut (1204), Straubing (1218) and Landau (1224). He also reformed the administrative system by splitting the duchy up into "offices", the precursors of today's various districts. The energetic duke notched up further success against the power-mad bishops of Passau, Regensburg and Freising who constantly squabbled with him over lands and estates. Veste Oberhaus, the mighty fortress in Passau, is a threatening manifestation of the religious rulers' attempts to cling on to power over hundreds of years.

The royal residence of Landshut boomed under the "rich dukes" of the 15th century. Ludwig of Kelheim had the old Landshuet, the wooden tower which defended both the roads and waterways, torn down and foundations laid for a spanking new castle high up on a rocky spur above the valley of the Isar. Burg Trausnitz became a royal seat in 1255 when the house of Wittelsbach's Lower Bavarian estates were partitioned off from those in Upper Bavaria and the Palatinate. In 1475 Duke Ludwig the Rich threw the most lavish party the Bavarian court had ever seen: the wedding of his son and heir George to Polish princess Jadwiga Jagiellon. In today's money he shelled out over 13 million euros on the wining and dining of his international guests…

Although the centre of power gravitated towards Munich during the 16th century, Landshut remained a place of art and culture. In the middle of town, opposite the fine Gothic brick church of St Martin's, work on the first Renaissance residence north of the Alps was begun in 1536. In 1578 the lords of the castle engaged the first Italian artists to breathe the joyous spirit of the Renaissance into the stark medieval stronghold with their illusionist paintings, one particularly fine example being the *commedia dell'arte* on the Narrentreppe staircase.

Following the Peace of Augsburg in 1555 Duke Albrecht V ordered his underlings to profess to the Catholic faith. Only Count von Ortenburg, who was self-governing, was able to manifest his Protestant beliefs.

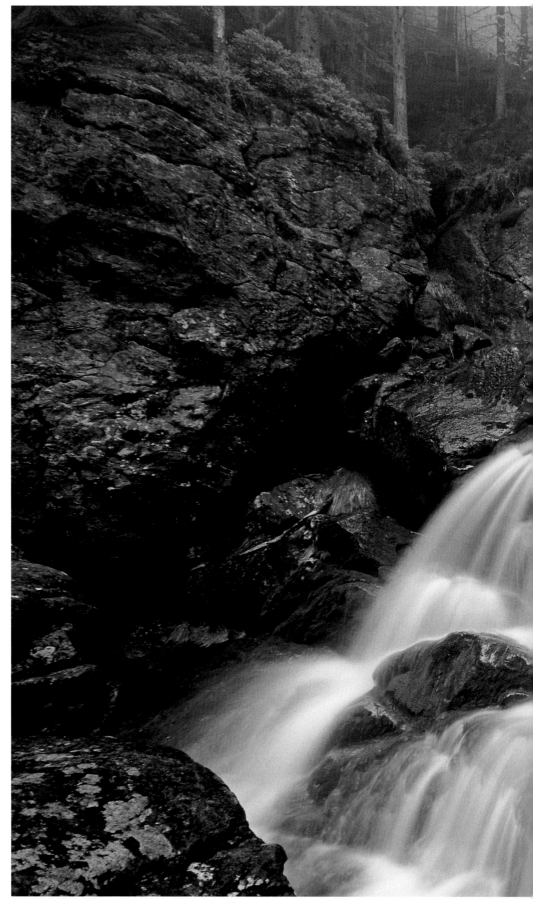

FLIGHTS OF FANCY: THE ART OF THE BAROQUE

During the Thirty Years' War (1618–1648) the Swedish army also laid waste to much of East Bavaria, with Gustav Adolf seizing Landshut. The plague epidemics of 1634, 1648 and 1649 only increased the sufferings of the local population who sought solace in religion. Pilgrimages were more popular than ever before. Donations from the general public helped to erect the most sumptuous pilgrimage chapels, cathedrals and parish churches. The slow recovery of the region was mirrored in the many stately homes constructed by the country nobility who liked to express their new-found selves through the art of the baroque. Only the woods of the Bavarian Forest remained ignorant of the general economic advance – right up until the beginning of the industrial age. Glass blowing didn't reap particularly great rewards for the workers – with the schnapps distilleries proving even less lucrative.

The baroque and Rococo were the last stylistic movements to be featured in the art and architecture of Lower Bavaria's villages. Neoclassicism turned out to be the reserve of the royal family, founded in 1806; Jugendstil only managed to establish itself in the applied arts. The local capacity for contemporary architecture was exhausted by the building of museums, such as the Roman Quintana near Künzing.

WITH SHARP MIND AND BITING TONGUE

Literature lagged somewhat behind the flights of fancy of the fine arts – even if famous minnesinger Wolfram von Eschenbach did entertain the courts of old with his epic poetry. Adalbert Stifter (1805–1868) was once enthralled by the magic of the woods and mystery of the mountains of the Bavarian Forest, the "land of stillness" – but he was Austrian. It has only been fairly recently that Lower Bavaria itself has found its voice, holding its own in the nation's cabarets and films. It all started with Walter Landshuter, who in 1977 opened up his Scharfrichterhaus or

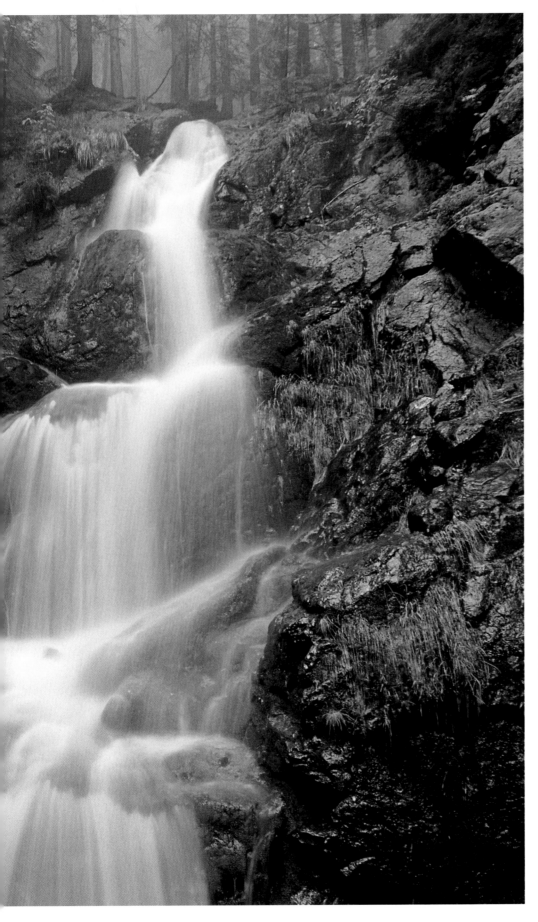

"executioner's den" in the old town of Passau and began staging his then revolutionary programme of biting political and literary satire. It was also here that a young Hape Kerkeling, famous in Germany for his impressions of Queen Beatrix of The Netherlands, first shyly presented himself to a critical jury at a talent show – and won. There are also a number of well-known cabaret artists from Lower Bavaria, among them Bruno Jonas, Ottfried Fischer and Sigi Zimmerschied, who delight in cynically and ruthlessly exposing mildewed political structures, scrutinising the role of the church and of course pillorying the cliques of major concerns and local politicians eager to make a killing in the *Woid* or Bavarian Forest.

EUROPE'S NEW CENTRE

What began with the fall of the Iron Curtain is being continued by the European Union's gradual expansion east. Lower Bavaria can positively redefine its position on the map and the Bavarian Forest has finally emerged from the shadows cast by the former Eastern Block. It now sells itself as a friendly holiday area, a stone's throw from the Czech Republic. The view east from Europe's green rooftop is no longer obstructed; tourism has become one of the major sources of income for the structurally disadvantaged Bavarian Forest. Holidaymakers and spa guests have also increased work prospects in the wellness resorts of Bad Birnbach, Bad Griesbach and Bad Füssing. The industrial sector, which gained new impetus from the railway at the end of the 19th century, is today largely dominated by the BMW plants in Landshut, Dingolfing and Regensburg. The increasingly prosperous glass industry, it has to be said, has sadly lost many jobs to automation – rather than creating them where they are needed most.

Page 22/23:
The waters of the Inn mirror the city of Passau and the early Renaissance monastery of the Capuchins. Despite its proximity to the river St Gertraud's was burnt down in 1662 and again in 1809, the latter disaster necessitating the building of the present neoclassical edifice.

Page 24/25:
Little pleasure boats chug along the straits of Weltenburg up towards the Danube Gorge, a spectacular narrow valley where the river forces its way through sheer cliffs.

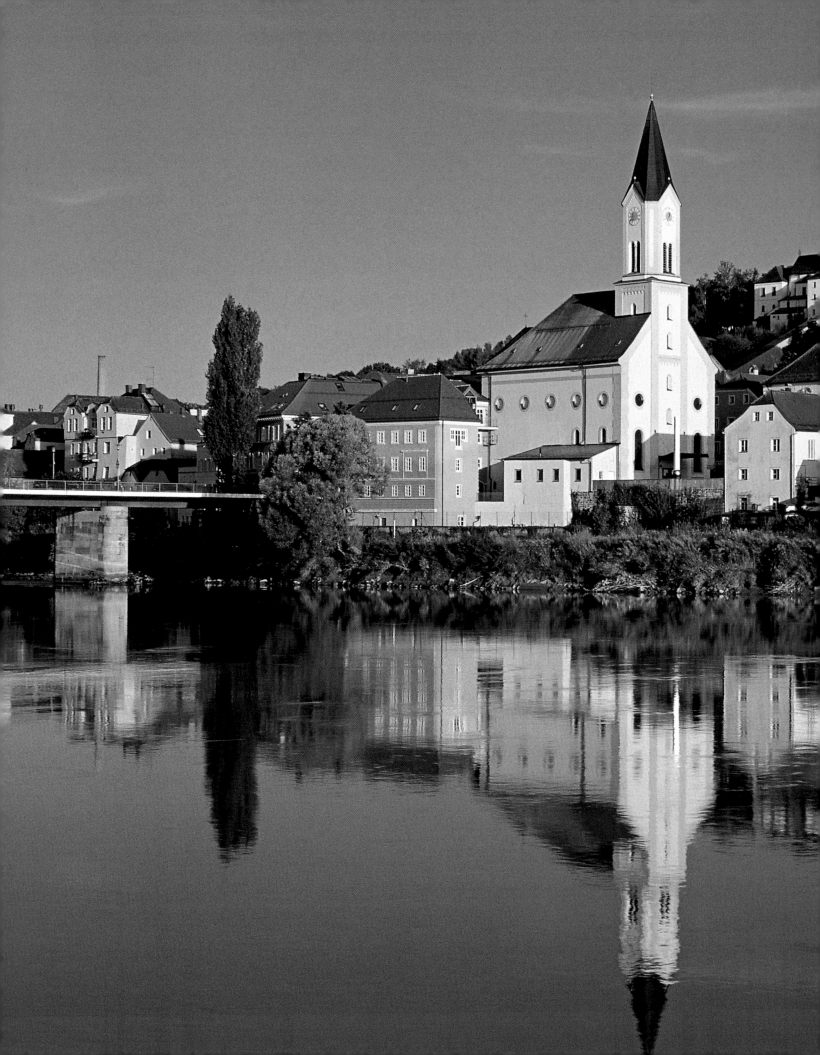

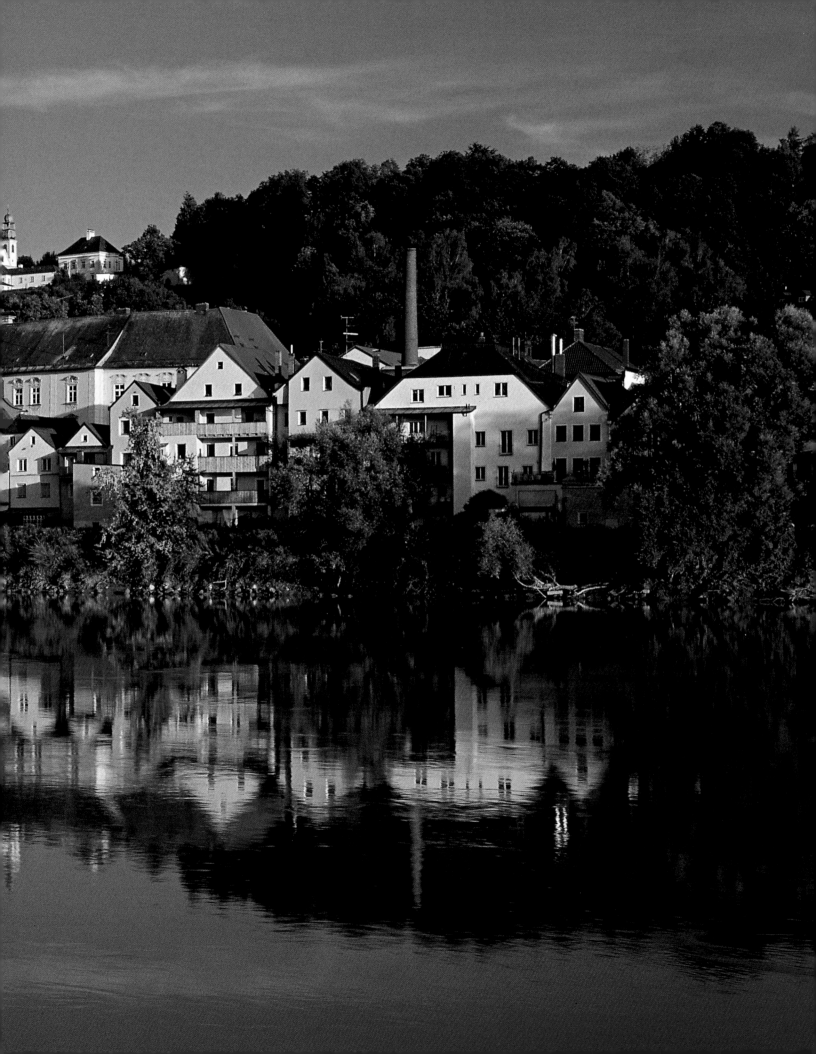

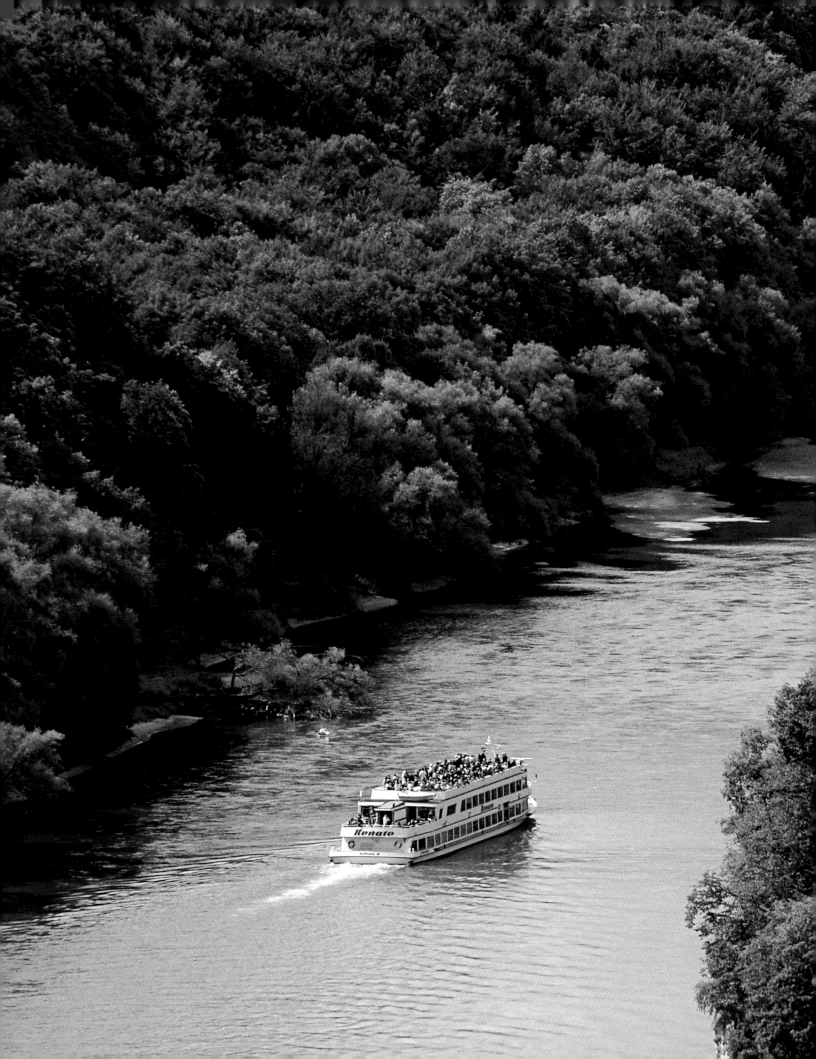

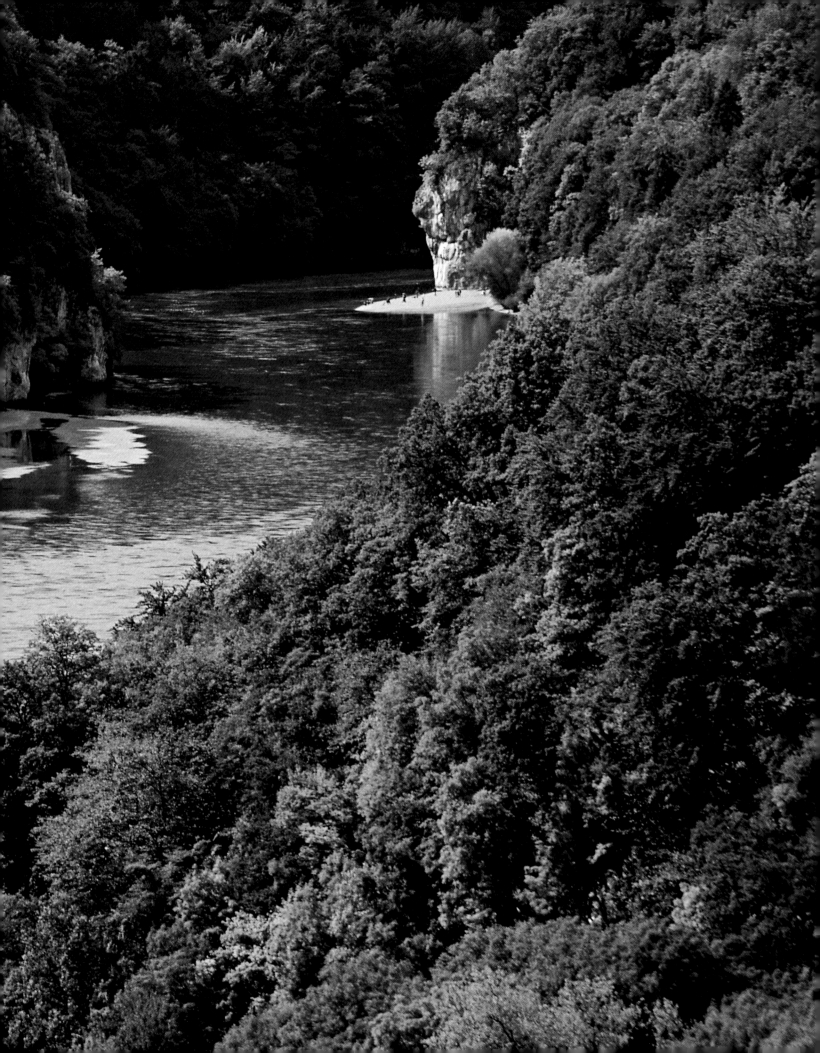

BETWEEN THE JURA AND THE GROSSER

The splendid baroque facades of the Neustadt in Landshut hide many secrets; underneath the decorative pomp the fabric of these colourful buildings is often much older. This street in the former ducal seat was once the site of a big grain market.

Journeying through the western reaches of Lower Bavaria is like travelling back in time, going back millions of years to the days when the ancient Danube River meandered through the Altmühltal and Stone Age man hunted mammoths – best embodied by the Schuler-loch dripstone caves near Essing. The valley of the Altmühl may now have lost some of its original character by having major shipping routes driven through it but the castles which line its steep banks at Riedenburg are still proud and mighty. The Danube Valley boasts one of the earliest monasteries in the region: the Benedictine abbey of Weltenburg with the oldest monastic brewery in the world. Welten-burg is also famous for the creative genius of the Asam brothers; the church is a prime example of effusive baroque joie de vivre and the glorious representation of the Holy Scriptures. Cosmas Damian and Egid Qurin Asam have also erected a monument to themselves in the monastery church of Mariä Himmelfahrt in Rohr. Another impressive local memorial is that commissioned by King Ludwig I high up above the confluence of the Altmühl and Danube: the Hall of Liberation at Kelheim which commemorates the wars of liberation and particularly the Battle of the Nations in 1813.

There are many other worldly delights to discover in the west of Lower Bavaria. Abens-berg is synonymous with first-class asparagus, for example; spa guests have been taking the waters of Bad Gögging since the Romans and the Hallertau – with Mainburg one of its chief market towns – has been the focus of diligent brewing activities since the 19th century.

Long before it was elevated to the status of provincial capital of Lower Bavaria under King Ludwig I in the 19th century, Landshut was the seat of local dukes. Burg Trausnitz still effuses a defensive medieval charm high up above the busy historic streets of the old town centre. Every four years the tapestry of Gothic and baroque houses draped around the hallowed halls of St Martin's provides a perfect backdrop for the town's biggest event: the re-enactment of the wedding of ducal heir George to his bride Jadwiga.

LAABER – THE WEST

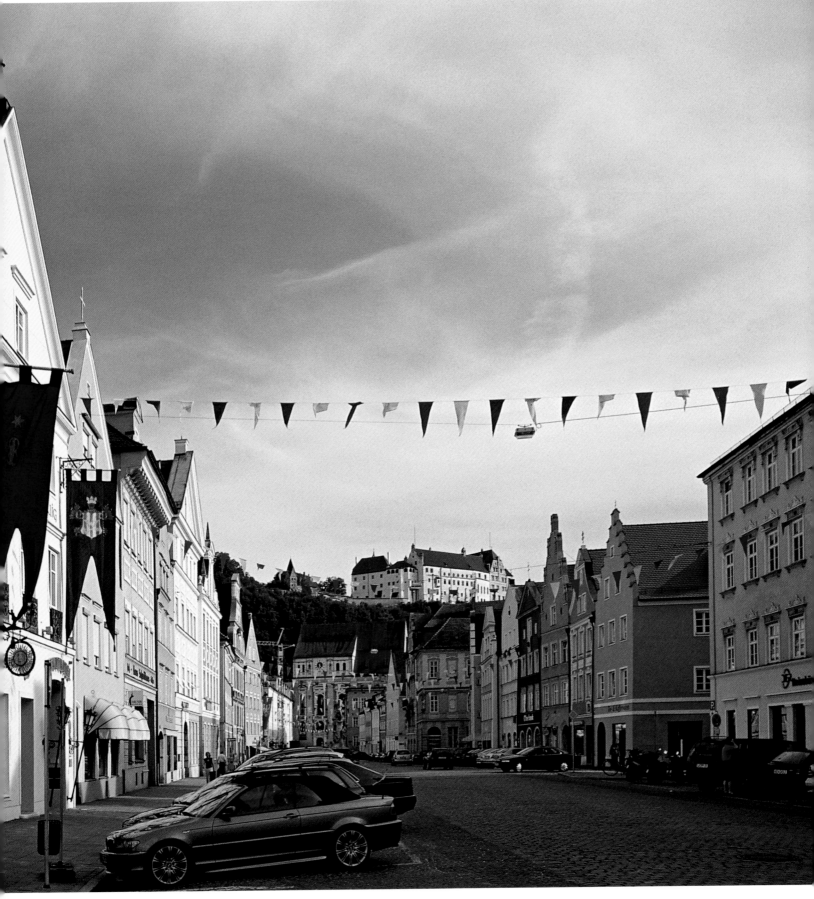

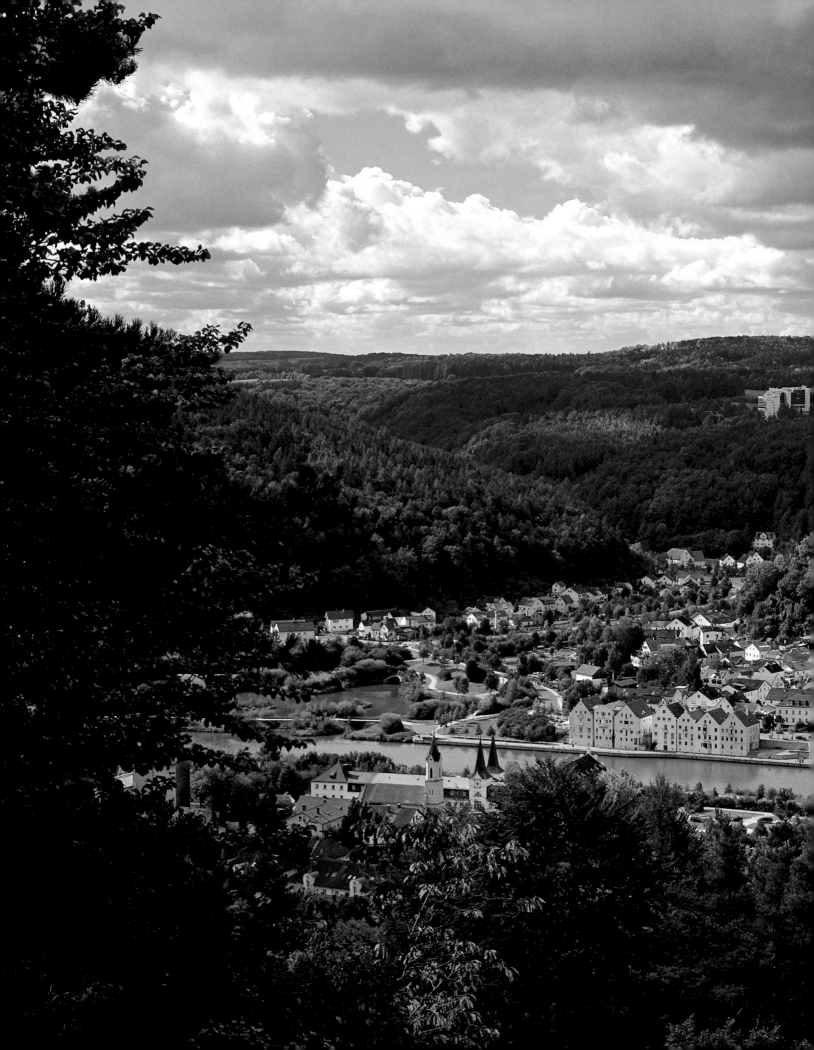

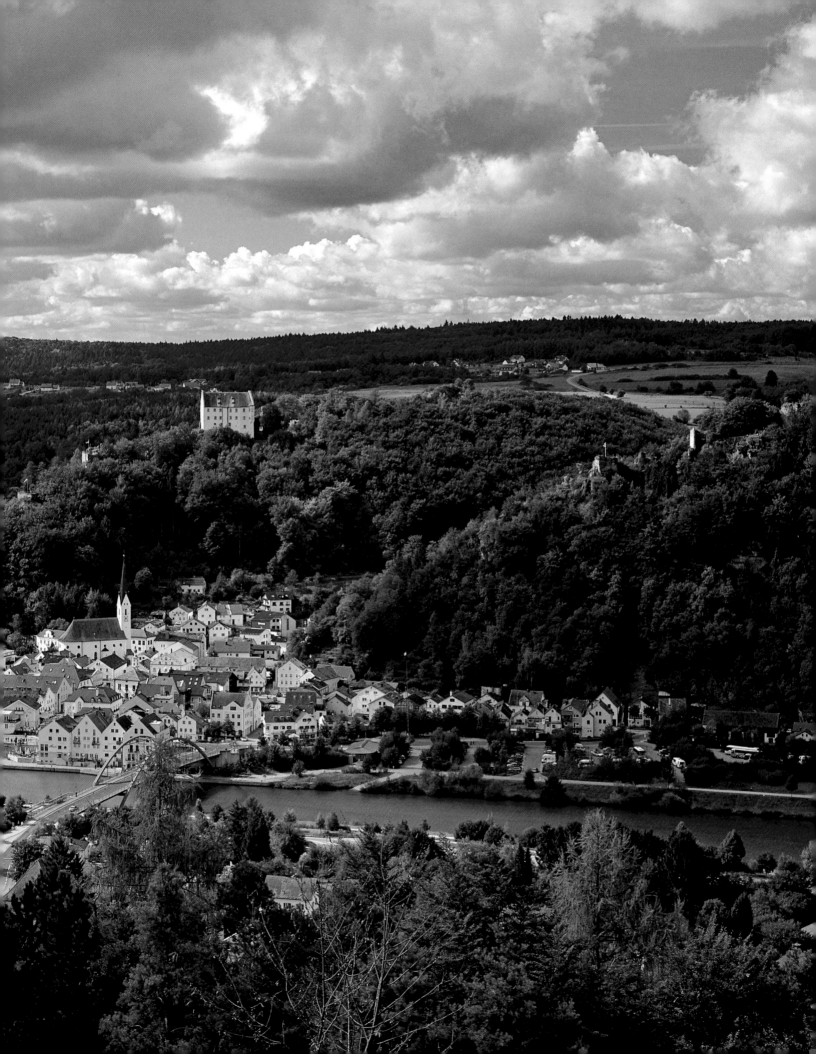

Top right page:
Like a giant wave Europe's longest wooden bridge rolls across the Main-Danube Canal at Essing. The planning and construction of this extravagant crossing took seven years; it was completed by architect Richard J. Dietrich in 1986.

Right:
Kloster St Anna in Riedenburg has been a regional school centre since the 19th century. Its medieval links are strong; the chancel dates back to the 14th century.

Page 28/29:
The small town of Riedenburg on the Inn has no less than three castles. The Rosenburg on top of the hill dates back to the Staufer dynasty; only ruins remain of the ancient strongholds of Rabenstein and Tachenstein below it.

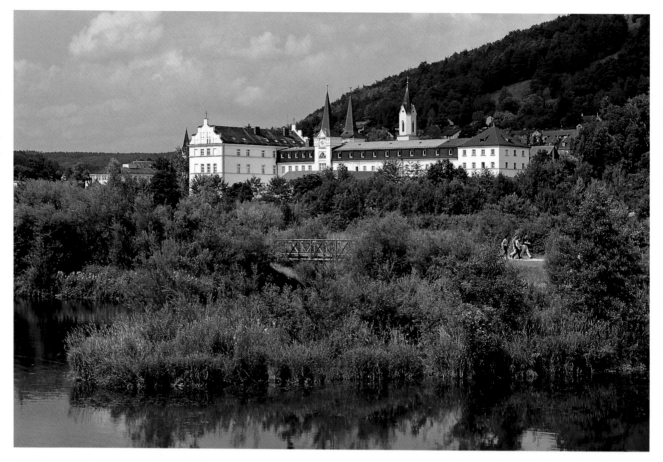

Right:
On the shores of this side arm of the Altmühl, here at Gundlfing/Riedenburg, hikers and anglers can enjoy the Altmühl Valley as it was before the extension of the Main-Danube Canal.

Bottom right page:
During the final stage of construction of the Main-Danube Canal a major Celtic burial site was unearthed near Eggersberg. The finds include garment clasps and a bronze belt from the 7th to 6th centuries BC, now on show at Schloss Eggersberg.

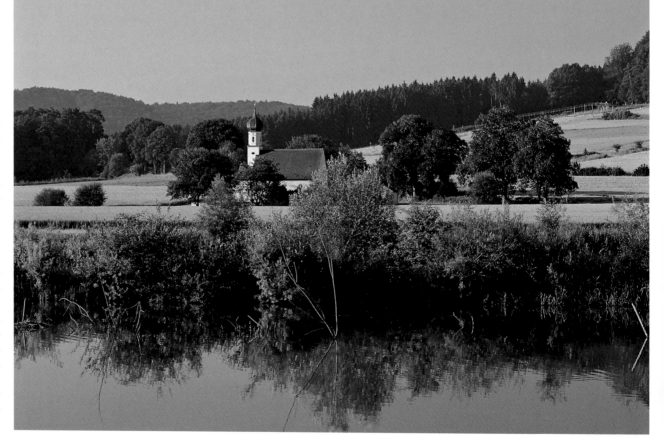

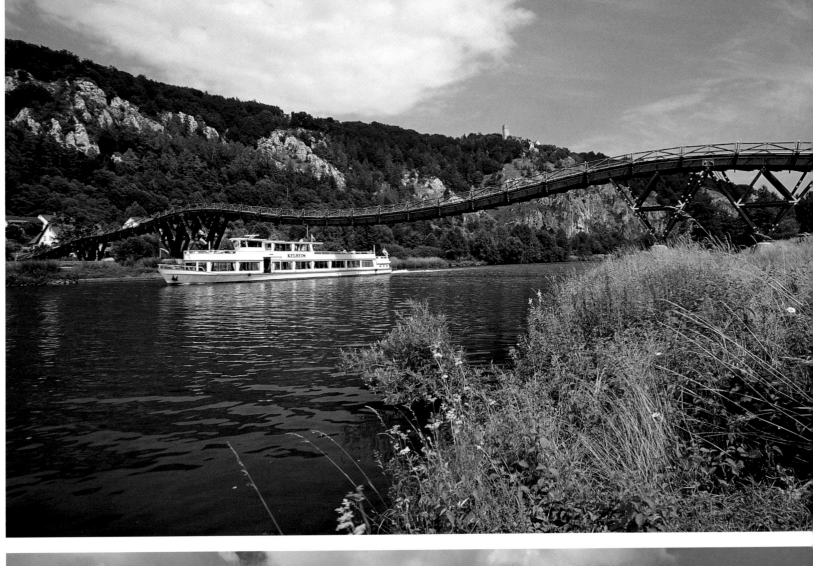
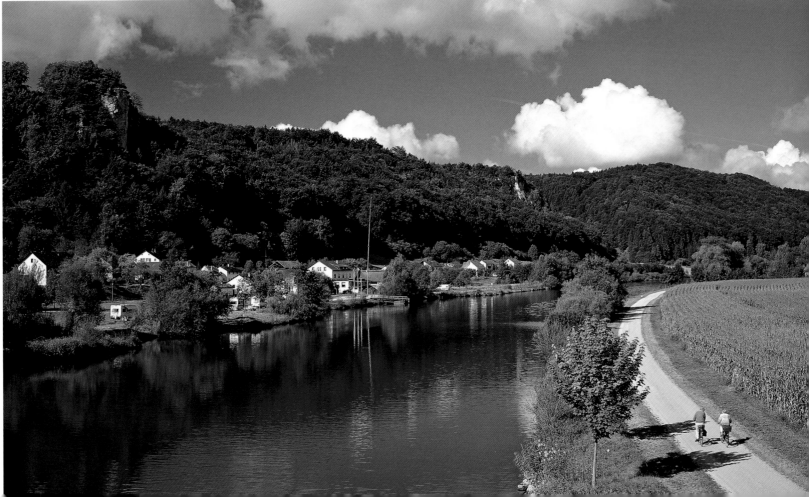

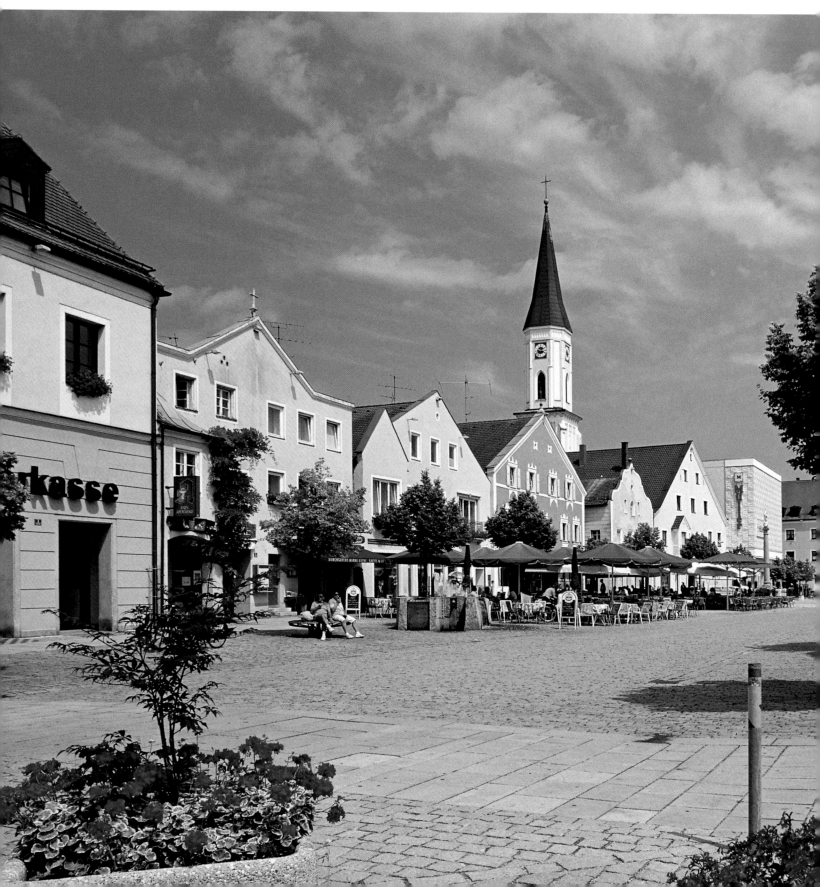

Below:
Kelheim positively boomed under the auspicious rule of the Wittelsbachs during the 13th century. On the terrible murder of the then local potentate, Duke Ludwig I of Kelheim, in 1231 the dynasty moved their seat to the supposedly safer territory of Landshut.

The Hall of Liber ation at Kelheim commemorates the wars of liberation and was commissioned by king of Bavaria Ludwig I. Completed by Leo von Klenze in 1863, his female statues represent the German tribes involved in the Battle of the Nations and the German states under Napoleonic rule.

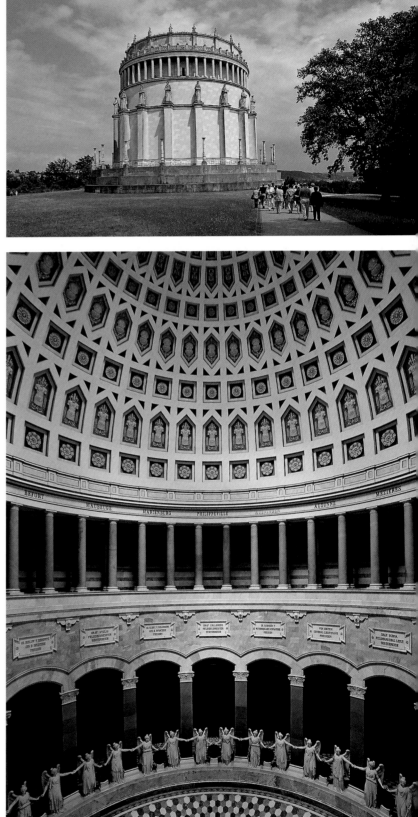

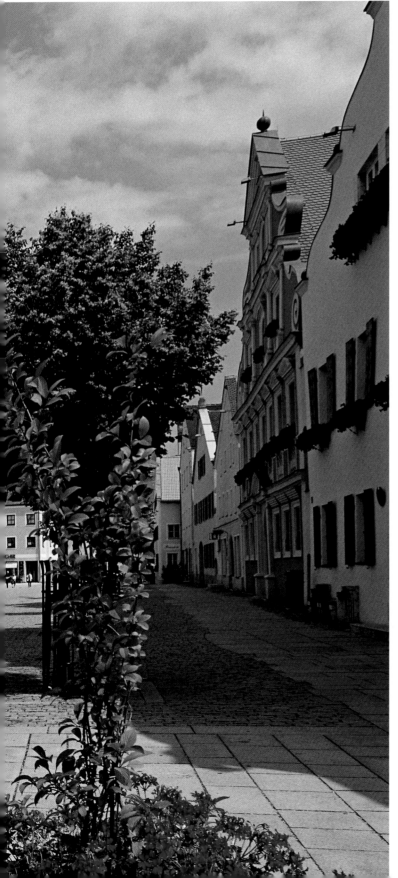

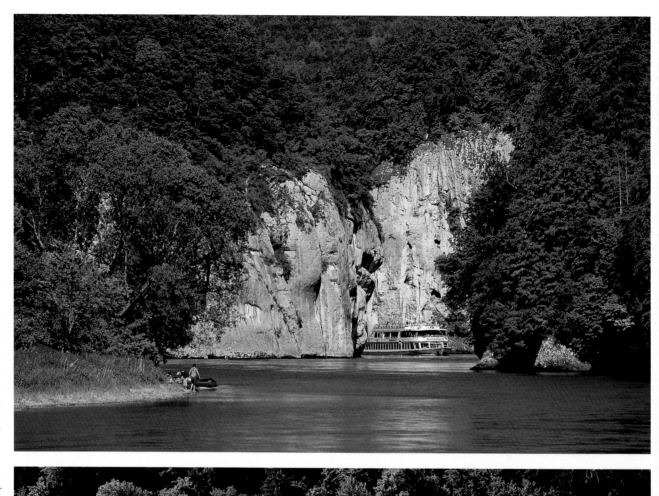

The Straits of Weltenburg is just one term geologists use to refer to the Danube Gorge downstream from the monastery of the same name. Less scientific vernacular designations include "Bayerischer Löwe" (Bavarian lion) and "Bischofsmütze" (bishop's mitre).

Precipitous cliffs to the north and rolling banks of gravel to the south hug the bend in the Danube at the monastery of Weltenburg.

Right page:
Although called the Danube Gorge, it was in fact tributaries of the ancient river which did much of the work in forming the ravine during the Riss glaciation. The Danube merely forced its way through the remaining 10 meters (30 feet) of rock to form the present canyon.

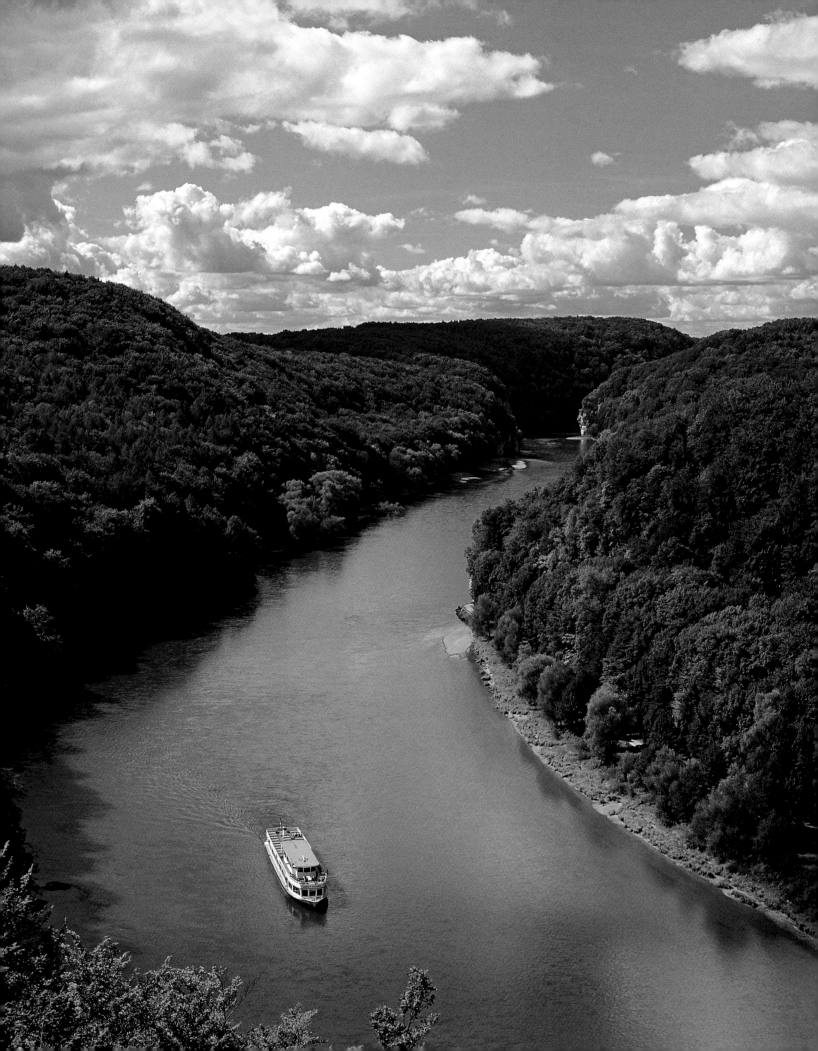

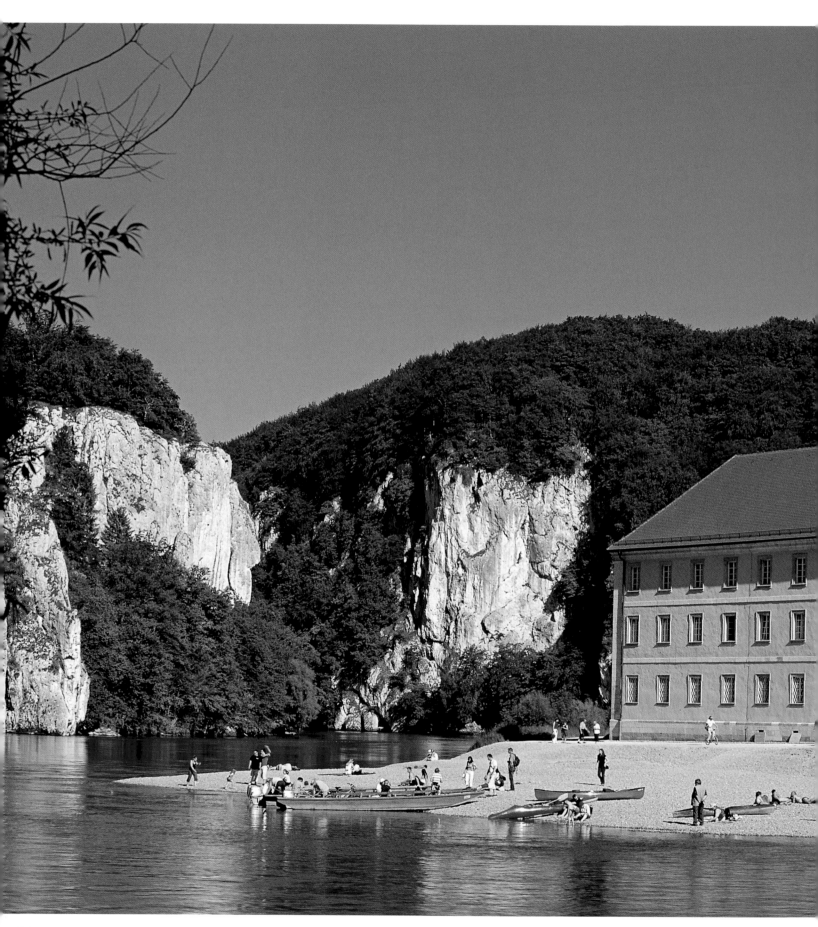

Below photos:
On their first commission at Weltenburg brothers Egid Quirin and Cosmas Damian Asam created a fantastic optical illusion. The baroque abbey church boasts an elaborate heavenly "dome" – painted on a completely flat ceiling. A stucco Cosmos Damian (top photo) challenges the observer to spot his artistic cunning...

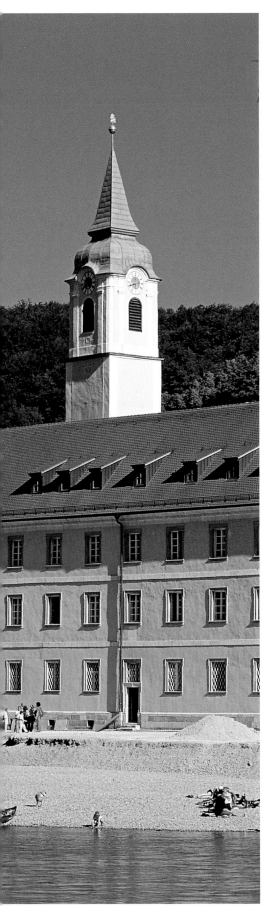

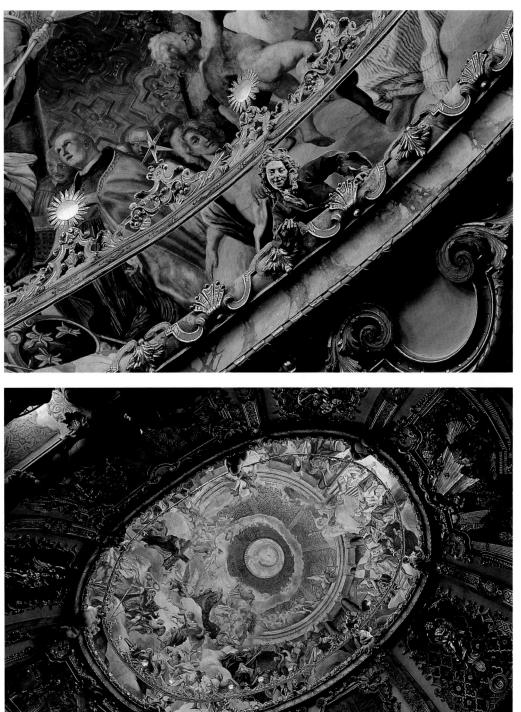

Left:
Bavaria's oldest monastery can only be reached on foot or by boat. Benedictine Weltenburg goes back to a cell founded by Irish-Scottish monks during the 7th century. With beer made here since 1050 it's also the oldest abbey brewery in the world.

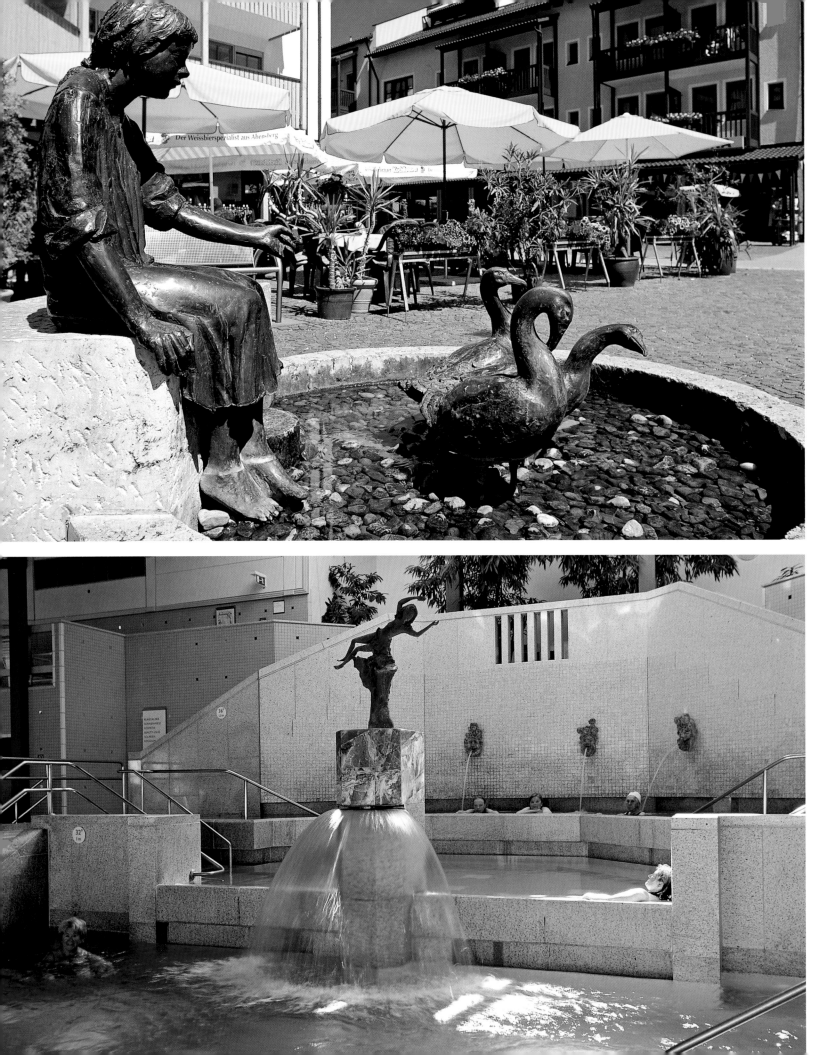

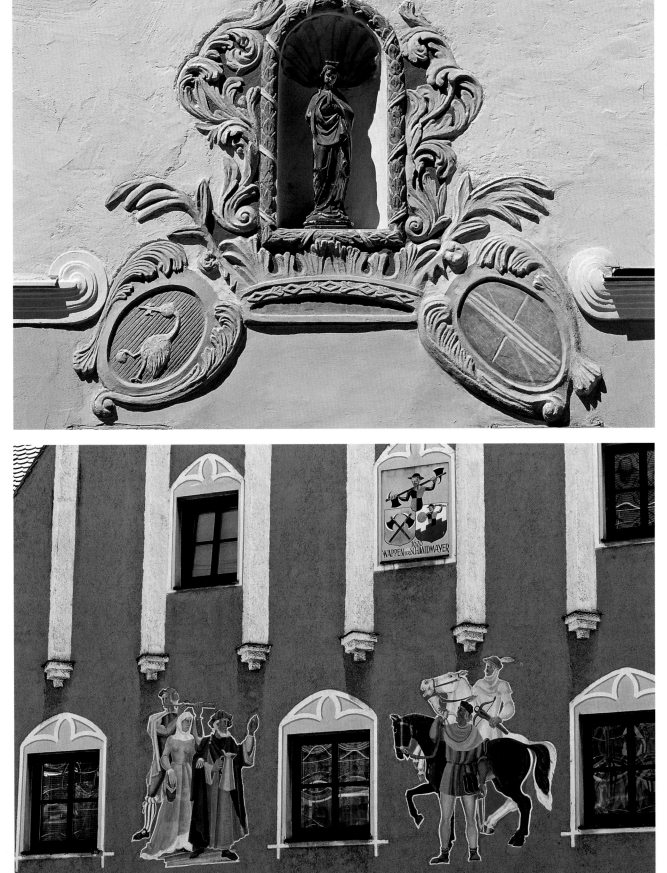

Top left page:
Gögging was only allowed to add the word "Bad" (spa) to its name in 1919 although the Romans had soaked in its sulphuric springs in the Limes fort of Abusina centuries before. The fountain shown here of a little girl and her geese is reminiscent of the days when farmers once grazed their flock here.

Left:
No other town in Bavaria has a charter as old as that of Neustadt an der Donau, granted by Duke Ludwig II in 1273. Not much has survived of the once formidable town walls and the Rathaus, shown here, had to be rebuilt after the devastation of the Second World War.

Left:
The 15th-century Gothic of the Rathaus was imitated by rich farmers who furnished their town dwellings with elaboration and extravagance. This building from 1935 illustrates the granting of the town charter.

Bottom left page:
It may not be Rome, but here at the Limes thermal baths in Bad Gögging we can still do as the Romans did: namely switch off for a few hours in the warm spa waters of this temple of health and beauty.

39

The many wayside crucifixes and chapels dotted about Lower Bavaria bear witness to the deep sense of faith harboured by the local inhabitants. People come here to pray for help and protection – and for fair weather to ensure a good harvest.

Far right:

St Mark, resting on the lion and legs dangling, is portrayed with elegance and lightness by Egid Quir in Asam on the pulpit of the abbey church in Rohr, consecrated in 1722.

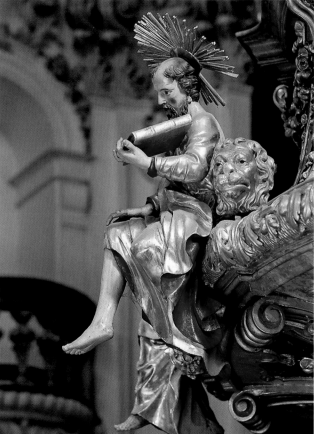

Right:

In the wake of the secularisation of Germany in 1803 the Gothic Carmelite monastery in Abensberg was given over to secular use. Both a school and hospital in its time, the restoration of the cloisters in the 1960s made room for a museum, named after chronicler Aventinus (1477–1534) who lies buried here.

Right page:

In 1717 Egid Quirin Asam was asked to design the monastic church of Rohr in Niederbayern. The climax of his Rococo masterpiece is the altar which depicts the Ascension of the Virgin Mary, its sense of drama and light provided by hidden windows.

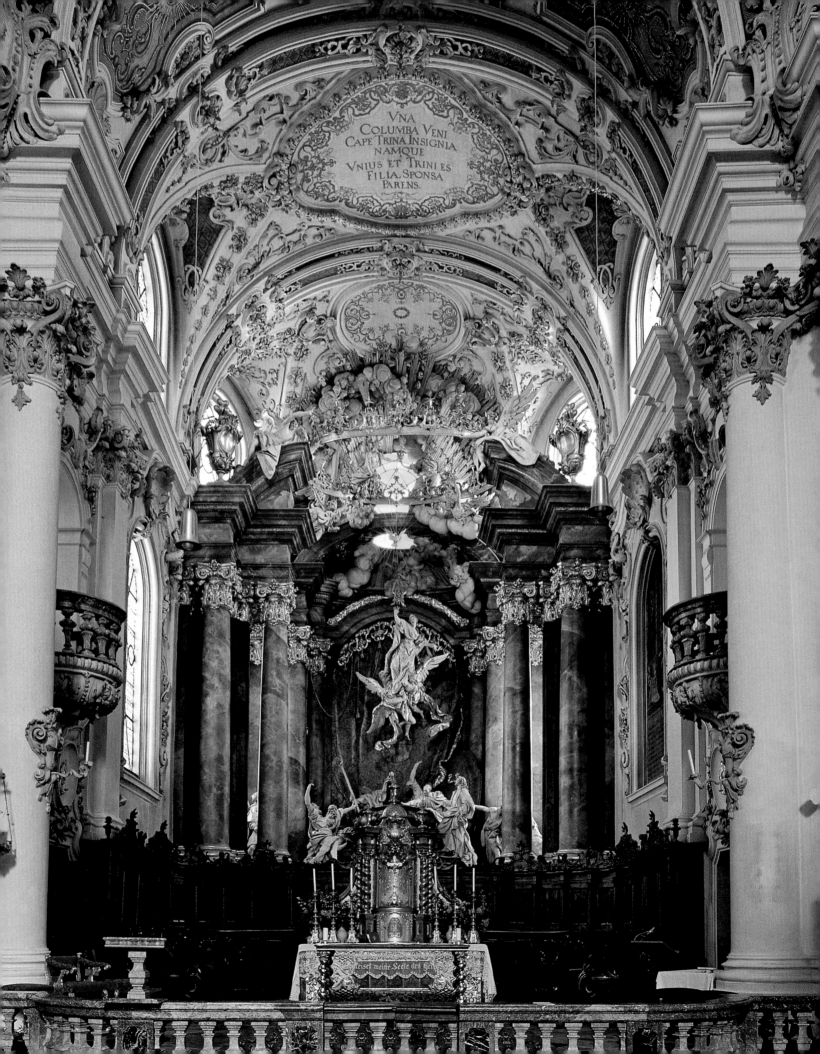

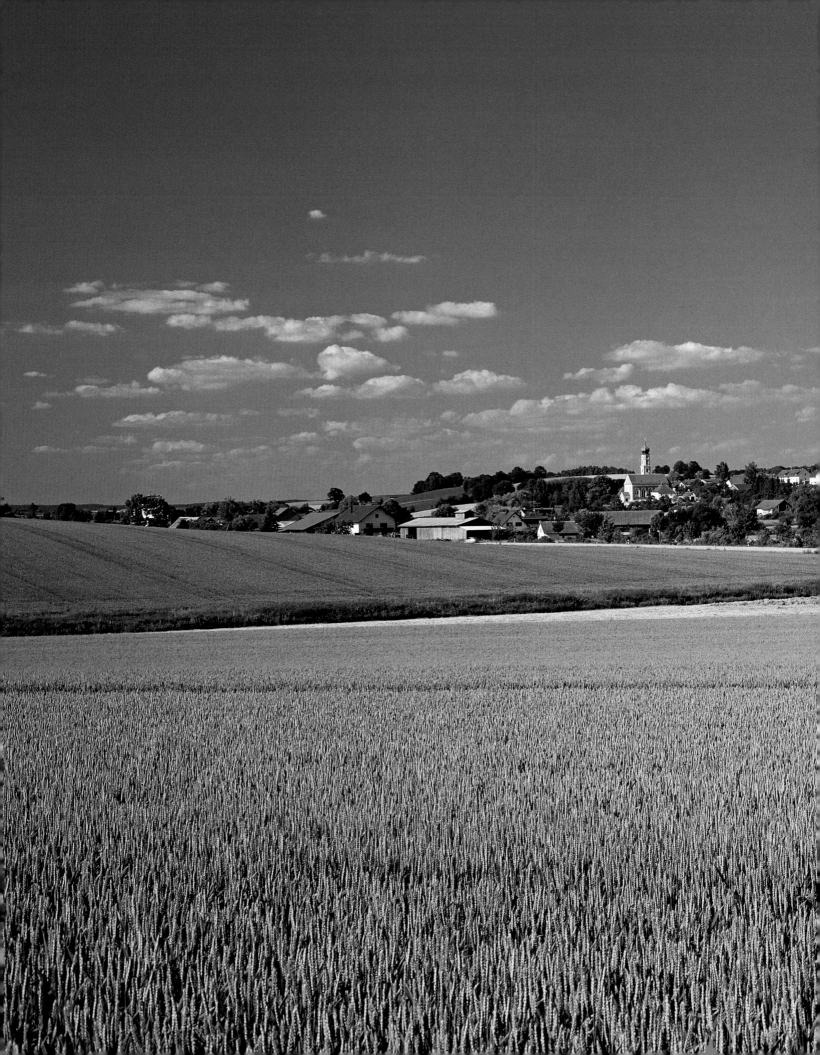

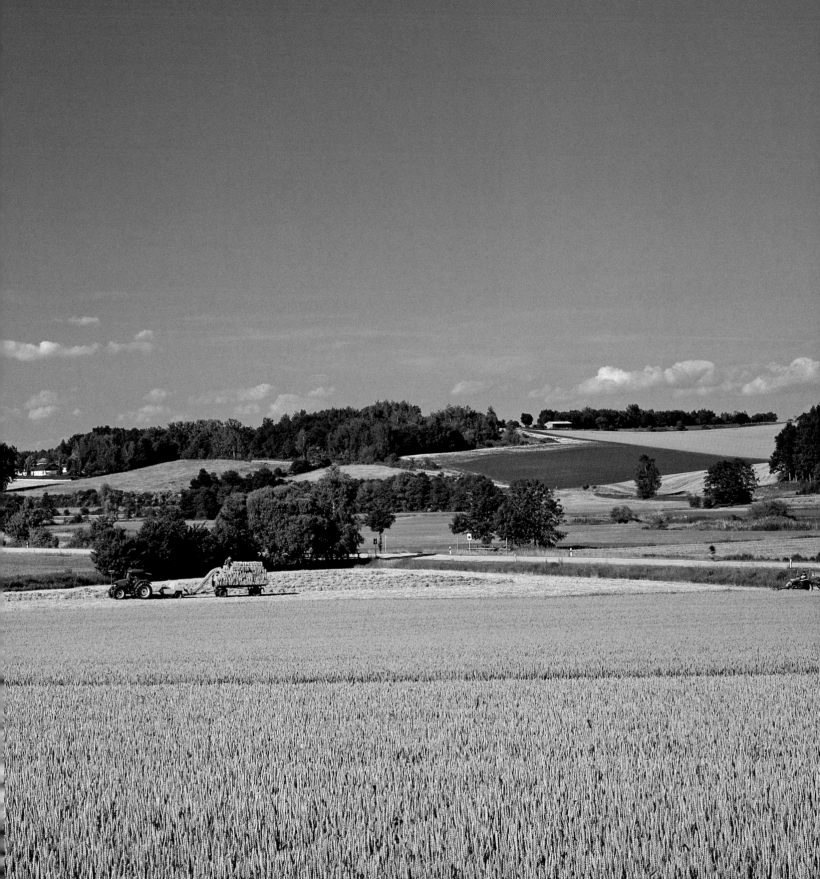

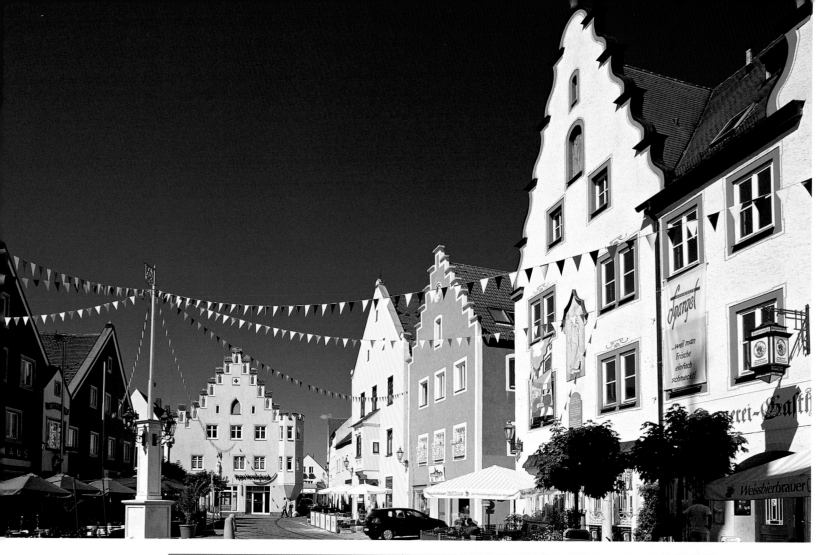

Above and right:
Abensberg boasts a magical old town and a splendid defensive wall which dates back to 1348. Humanist and founder of our modern written history Johannes Turmair or Aventinus was born here in 1477. The town is now better known for its excellent asparagus.

Page 42/43:
In the open fields of the Laaber Valley the pilgrimage chapel of Mariä Opferung is a distinctive landmark on the route to Laaberberg. The chapel was erected in the baroque fashion in 1703; the much older image on the altar is said to have miraculous powers.

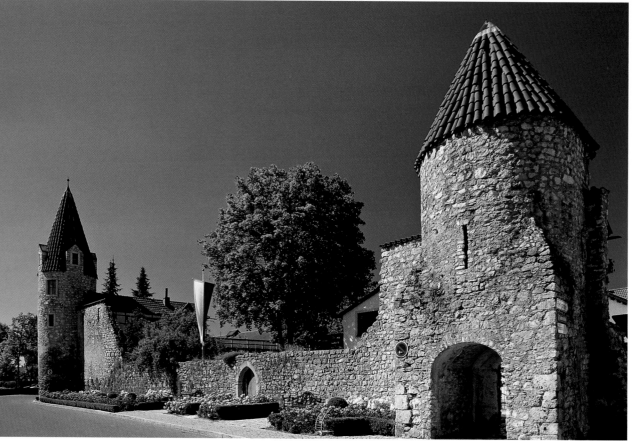

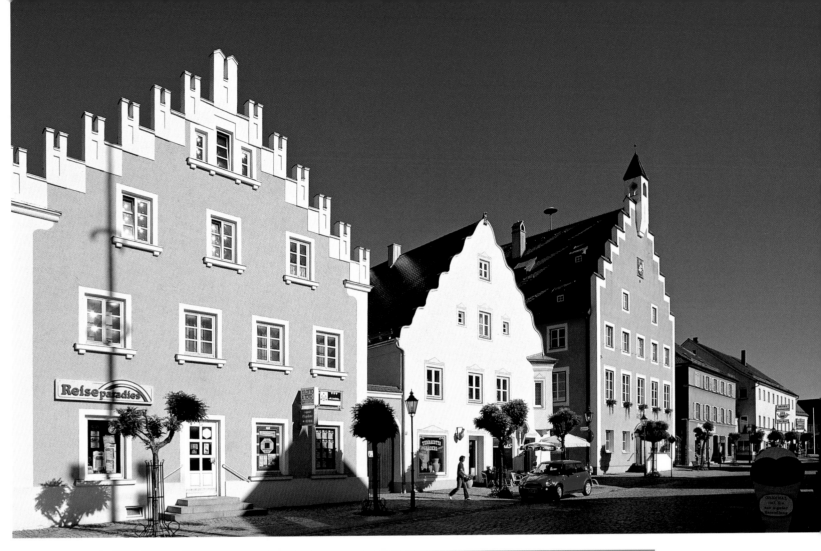

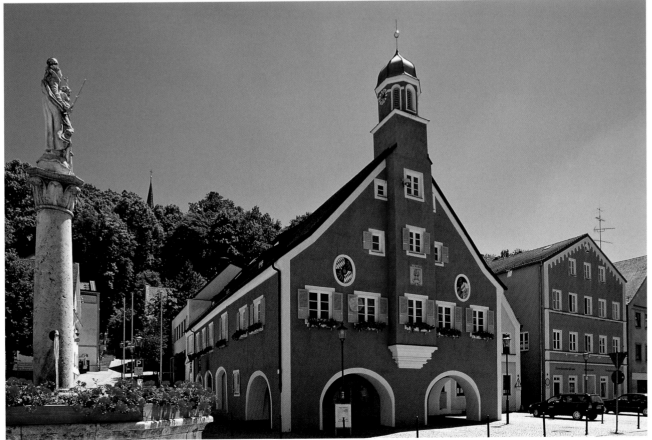

Above:
In the fertile valley of the Großer Laaber lies the old Hallertau market town of Langquaid. The stately town dwellings on Marktstraße were once the home of well-to-do farmers who grew rich off the profits from arable and livestock farming.

Left:
Mainburg was caught up in the mangles of war for centuries. Peace and prosperity only set in during the 19th century when hops began to be farmed on a grand scale. The cones were weighed outside the Rathaus, shown here, and stacked in sacks under the arcades.

HOPS AND ASPARAGUS –

Even the brewers in Monterrey, the beer capital of Mexico, have heard of the Hallertau, never failing to sing the praises of its hops. The world's largest hop-growing area begins about 35 kilometres (22 miles) north of Munich, its hop-tented summer fields creating a bizarre disjointed landscape in winter – as if Christo and Jean-Claude had created one of their wood-and-wire installations here on the frozen hills and icy slopes. Hop farming turned big during the 19th century, the quality of the crops indicated by the seals which were allocated to the various estates. In the Middle Ages the hop market was controlled by the Hanseatic merchants of North Germany, with Spalt in Middle Franconia and the Elbe-Salle region the most prolific areas of farming.

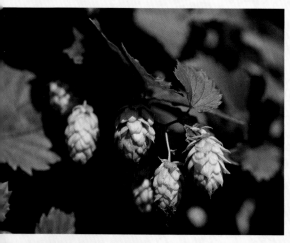

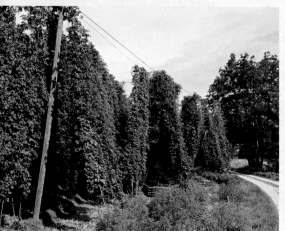

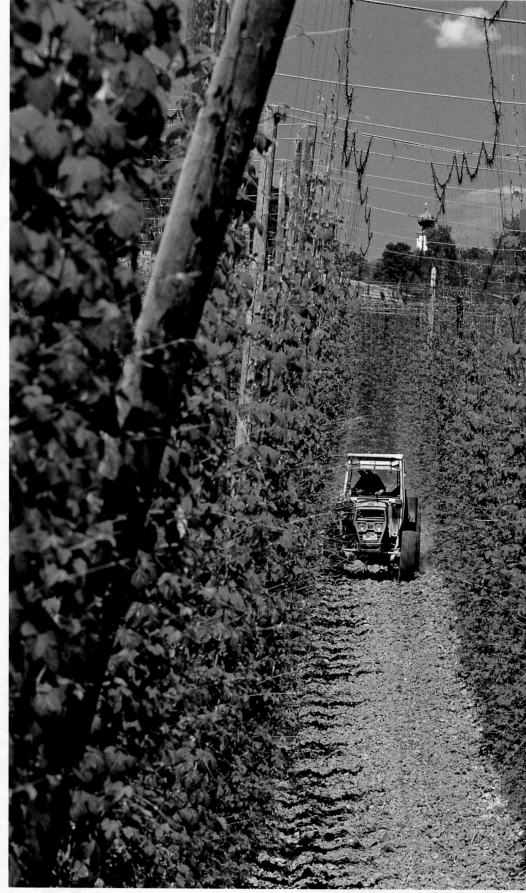

THE CULINARY DELIGHTS OF THE HALLERTAU

It doesn't take much to turn hops into beer. Where *Humulus lupulus* thrives (a member of the hemp or cannabis family), so do wheat and barley. These – with water – are the other major ingredients in beer and have played a not inconsiderable role in the long brewing tradition of the Hallertau. Once upon a time the hop gardens in the south stretched as far as Weihenstephan, the site of the oldest brewery in the world, where in 1040 Benedictine monks started production on the granting of a licence to brew. Before Carl von Linde invented his new method of refrigeration the vaguely alcoholic beverage was a winter drink. Regardless of the fact that strong light beer was to supplement the less substantial solid diet during the period of Lent, it was the last liquid produced before the summer break and thus had to be especially strong so that it kept. As the temperature rose outside, the bars of ice packed in straw which insulated the beer barrels in the cold cellar began to melt – and the beer quickly went off if it was too weak.

Modern cooling technology enables beer to be brewed and stored all year round. Mechanisation has considerably eased hop farming – from the planting of the hop yards to the harvesting of the crops. Where hoards of hop pickers used to laboriously snip each cone from the wires or bines, today the automated hopper removes both hops and bines, tearing them off their supports and loading them onto the cart. The cones are then mechanically stripped from the bines, dried and packed in enormous hop kilns. The powdery hop flour from the cones, the stuff which actually flavours the beer, is sold as an extract or in pellets.

NECTAR FOR THE TASTE BUDS

Another local culinary tradition centres on hop asparagus, the pencil-thin shoots of the rampant climber which from mid-March to mid-April occasionally feature on menus in select restaurants. Even today just three tendrils per plant are grown; the others are pruned off. For many years the delicacy was simply discarded; today it's experiencing something of a comeback as a tasty (and costly) vegetarian novelty.

Asparagus of a very different nature and in much greater qualities is yielded by the fertile sandy soil of the Abensberg. The increasingly popular vegetable has been planted here for around 90 years. Roman consul Cato the

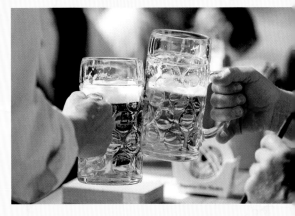

Elder described the low-calorie vegetable in his farming manual as "nectar for the taste buds"; even privy councillor Johann Wolfgang von Goethe was so enthusiastic about it as to personally tackle the overgrown asparagus beds in his Weimar garden. Asparagus is plucked early in the morning from the beginning or middle of April (depending on the weather) to June 24 or the feast of St John (Midsummer). Hundreds of metres of plastic cover the earthed-up mounds which keep the tips of *Asparagus officinalis* white; just the tiniest amount of sunlight colours them purple, intensifying their delicate taste. Green asparagus, such as that cultivated in the Vale of Evesham in England, for example, is grown on flat fields and eaten with the skin – unlike white asparagus, which has to be laboriously peeled. Both varieties are classically served with melted butter or a creamy sauce and ham – and whatever the colour or method of preparation, the taste is superb!

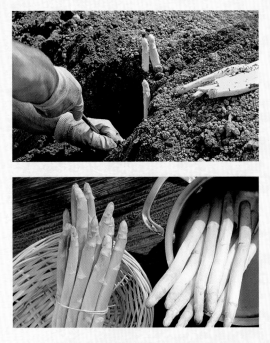

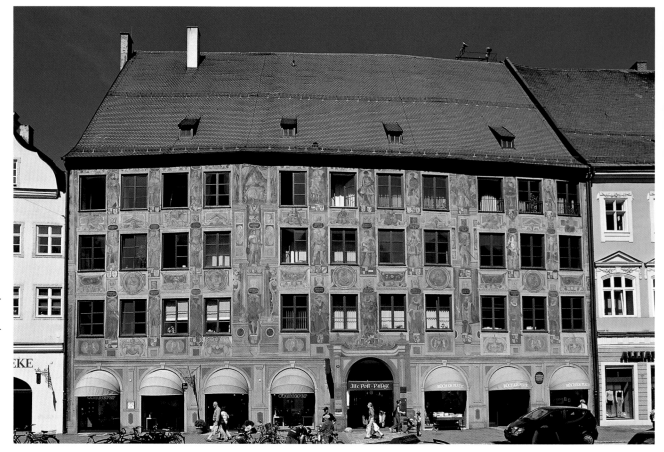

Right:
Still used as a post office in the 19th and 20th centuries, this building in Old Landshut used to be where representatives from the town, clergy and nobility held council.

Below:
In 1536 Ludwig X of Bavaria moved down from his fortress of Trausnitz to the comfort of a residential palace he had built in the heart of Landshut. A trip to Italy inspired the duke to endow his new home with an Italian wing.

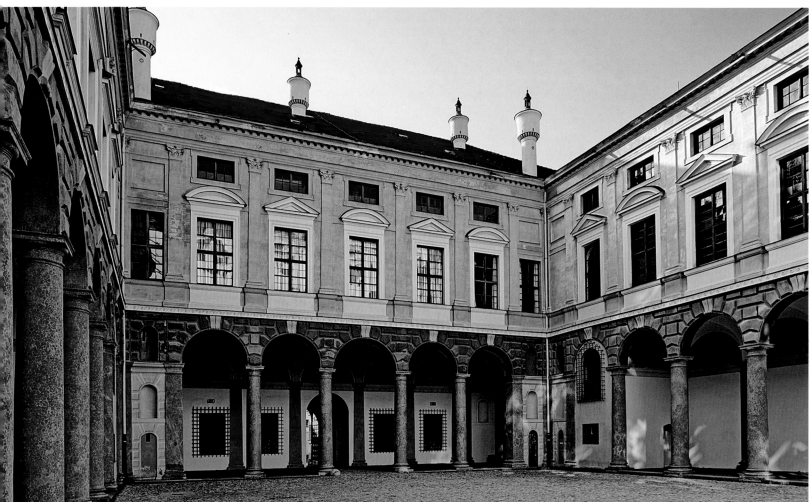

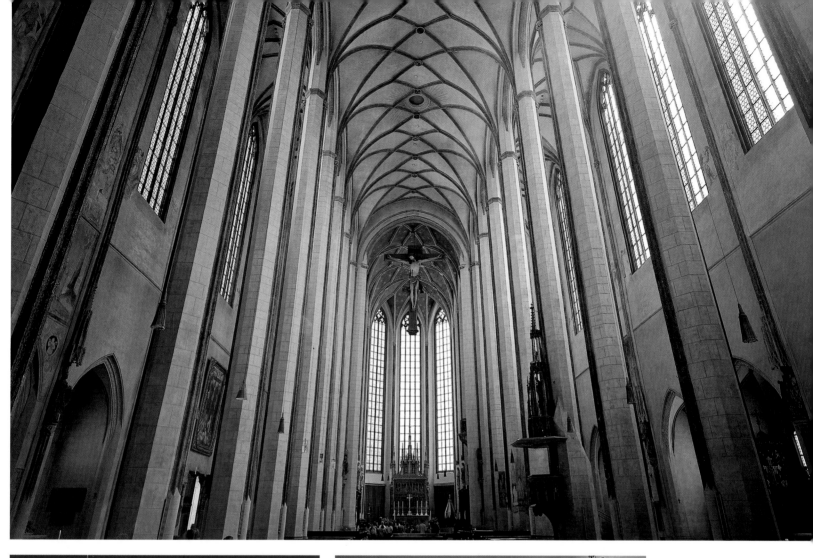

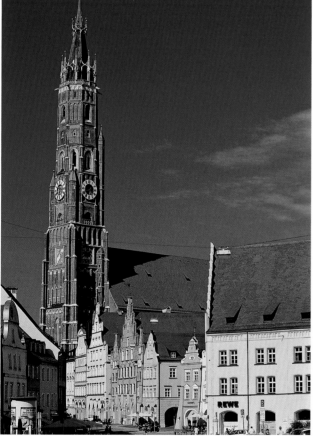

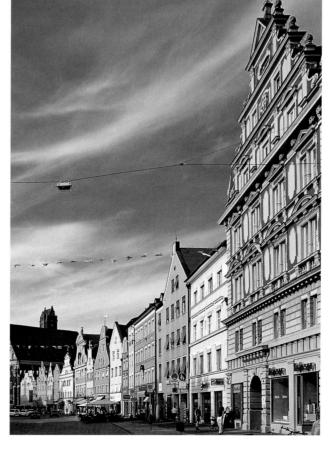

Above:
*Lofty and majestic,
the nave of St Martin's
in Landshut has three
sections, making
it an aisled basilica.
The Gothic church
was begun in 1387.*

Far left:
*The steeple of St Martin's
is perfect fodder for the
Guinness Book of Records;
at 131 m (430 ft) it's
the highest brick belfry
in the world.*

Left:
*Magnificent facades from
the Gothic, Renaissance
and baroque periods
line the Altstadt street
market in Landshut
from St Martin's to the
Heilig-Geist-Kirche.*

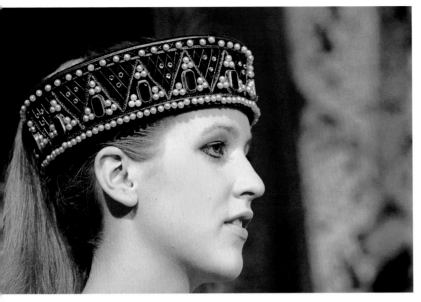

It was the biggest and most expensive feast of the late Middle Ages: the wedding of Georg, son of the duke of Bavaria, Ludwig the Rich, to Jadwiga, princess of Poland, in 1475. Got up in costumes modelled on original dress from the period, every four years Landshut re-enacts the event, complete with camps on the banks of the Isar, medieval tournaments and a glorious procession.

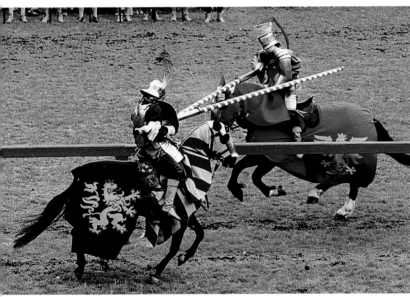

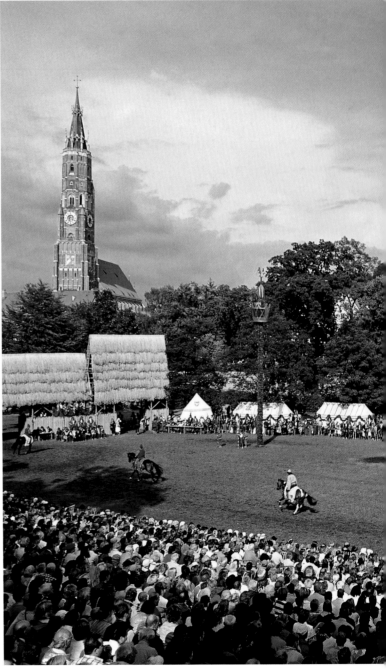

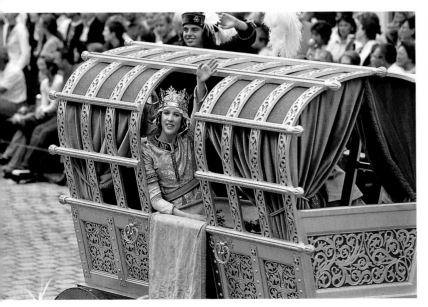

At the Rathaus play visitors can follow the mildly humorous journey of the young princess coming to meet her bridegroom in 1475. Jadwiga's trip from Krakow via Berlin, Wittenberg and Nuremberg to Landshut took two months; she arrived late. The chief players have to be better organised today, especially the men whose hair has to be grown down to at least their chins if they want to join in the jollities!

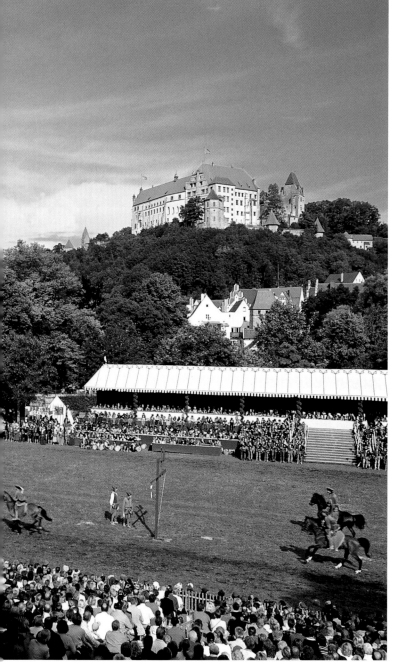

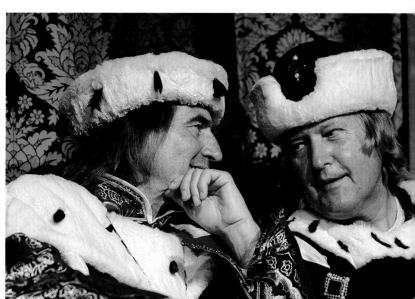

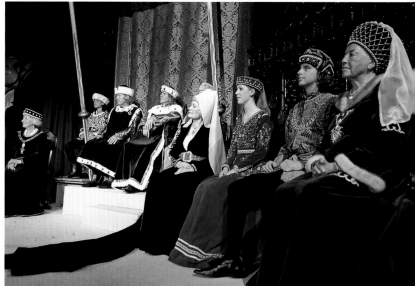

Above:
The Renaissance palace in Neufahrn was begun in the first half of the 16th century.

Right:
Schloss Neufahrn in Lower Bavaria suffered severely from the plundering of the Thirty Years' War. After having changed hands several times and subsequently fallen into decay, the palace has now been turned into a luxury hotel where delicious fare and comfortable rooms eagerly await welcome guests.

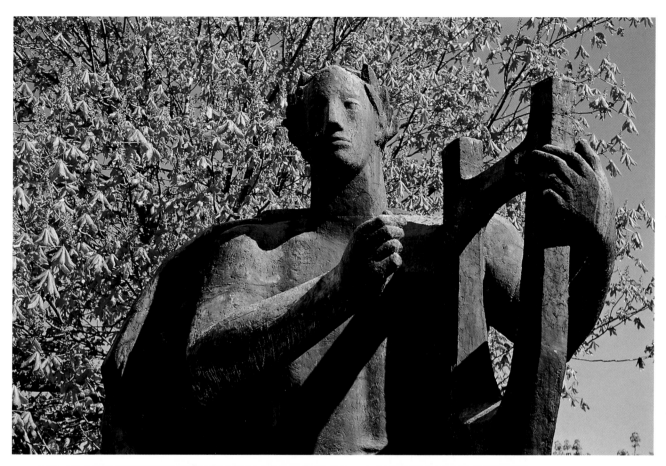

Left:
The stone original of this statue of Apollo now adorns the gable of Munich's national theatre. Sculptor Georg Brenninger (1909–1988) from Velden bequeathed to his native town this bronze cast of the Roman god of the arts.

Below:
Like Munich, which owed its evolution to a bridge over the River Isar, the village of Pipurch was also built at a crossing, here traversing the River Vils. The village was fortified by the dukes of Wittelsbach in the 13th century and is now known as Vilsbiburg.

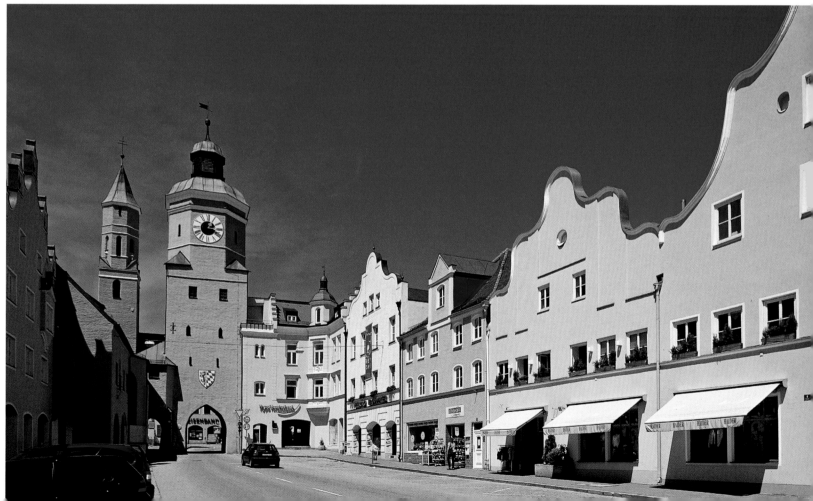

Built on the site of the Roman fort of Strupinga, during the Middle Ages Straubing became a humming centre of trade serving the fertile reaches of the Gäuboden. The town skyline is marked by towers: that of the Stadtturm on the market place from the 14th century, the brick steeple of the Carmelite church, the belfry of St Jakob and the water tower of the Gründerzeit.

I n the stretch of country between the Danube and the Inn rivers have eased the passage of trade and transport for thousands of years, their fords and bridges providing perfect sites for new settlements. Archaeologists have un-earthed a fortified Celtic fort a few kilometres downstream from the regional capital of Strau-bing; this is where the Celts once tilled the land, starting a farming tradition the Romans later continued to supply their limes forts at Stru-pinga and Quintanis (near Künzing). Important finds from this period are major attractions at the museums in Straubing, Landau an der Isar and Künzing.

Like many of the major cities and market towns wending their way down to the River Inn Straubing was founded by the house of Wittels-bach. The dynasty – or rather Albrecht III, the son of Duke Ernst of Bavaria – is inextricably linked to the fate of one Agnes Bernauer. Mar-ried secretly and above her station to Albrecht, the daughter of a village quack was drowned in the Danube at the instigation of the duke of Bavaria in 1435. Straubing's Gäubodenfest is a much less gruesome affair. The biggest public festival in Lower Bavaria dates back to an agri-cultural market first held in 1812, complete with horse racing and stud shows. The beer tents and funfair rides are now as popular as the yield of the Gäuboden pastures is opulent.

Whether Landau, Dingolfing, Vilshofen, Eggenfelden or Pfarrkirchen: all of these ancient centres of trade sport elongated market places lined with splendid town residences as a badge of their mercantile success. Following the Thirty Years' War many rural parish churches and monasteries donned fashionable baroque onion domes and local aristocrats had their stately homes decoratively embellished. The three spas of Birnbach, Griesbach and Füssing were given a new leash of life in the 1970s when the bubbling hot springs were fed into new, chic temples of wellness and healing. The in-habitants of Passau unfortunately often have more water than they need when the contents of the Danube, Inn and Vils rivers reach record levels. The frequently flooded city was glorified by the prince-bishops of old, its massive cathe-dral, episcopal palaces and the Mediterranean flair of the old town still a great magnet for vis-itors – whatever the weather.

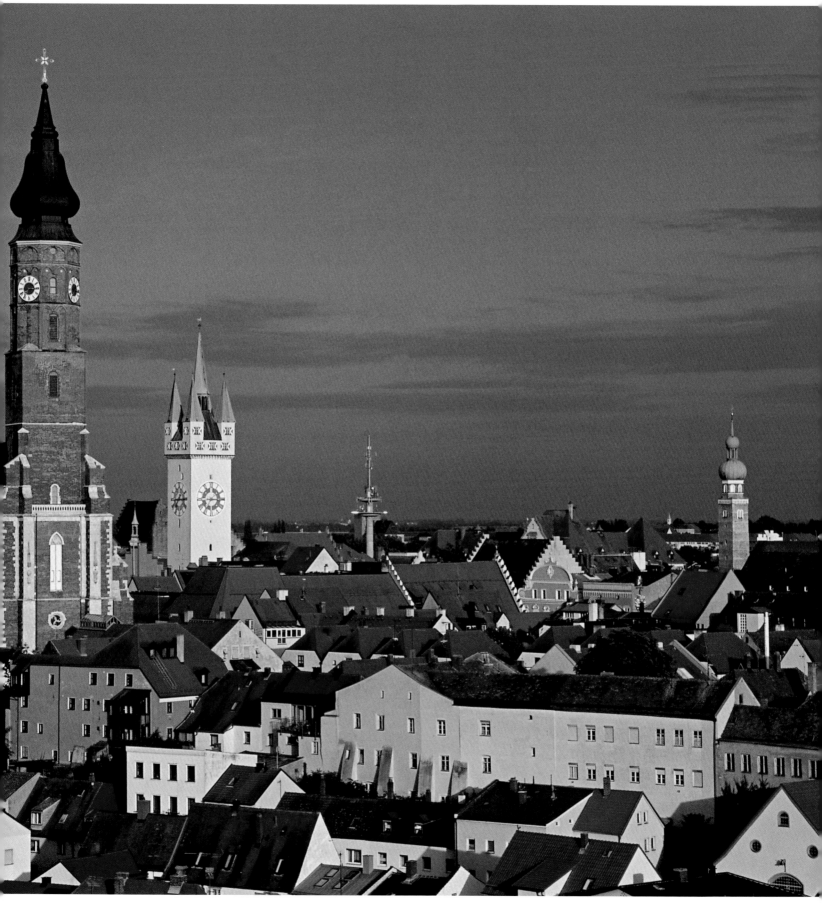

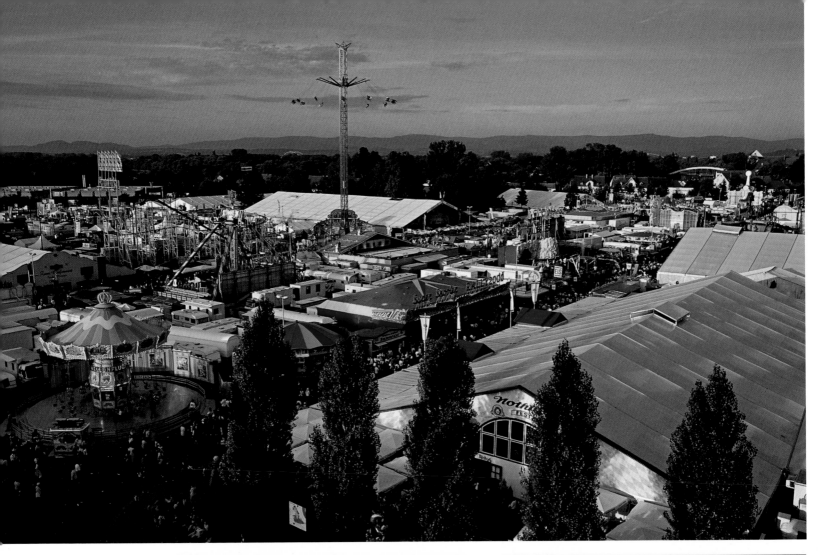

In order to celebrate the fruitful harvests of the Gäuboden, in 1812 Straubing was granted permission to hold a festival to this end by King Maximilian I. Similar to Munich's Oktoberfest the celebratory market has now become an 11-day event, complete with the newest, loudest, giddiest techno rides.

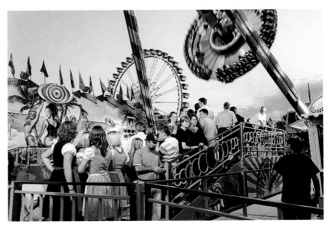

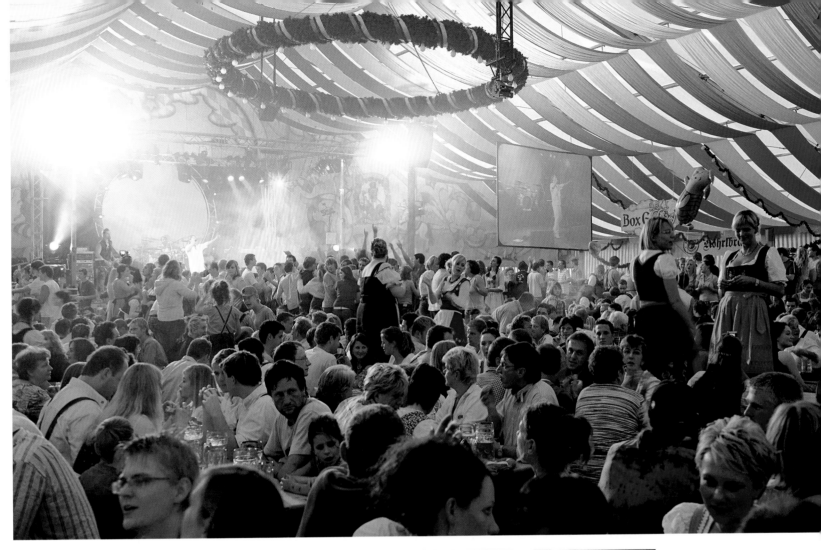

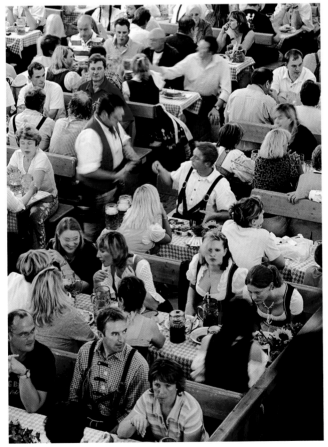

1.2 million visitors came to the Gäubodenfest in 2007, many of them in dirndl and Lederhosen. With a multitude of foaming beer, roast meat and fried fish to keep everybody happy, the festivities go on well into the night.

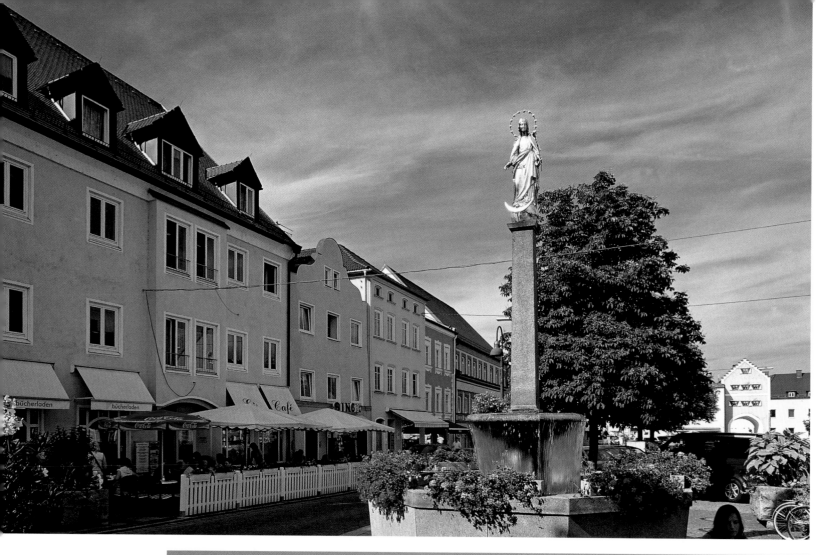

Above:
The market place in Dingolfing is steeped in the nostalgia of the Middle Ages, very different from the industry which the city is now famous for: cars. In 1973 BMW took over Glas GmbH and built up a production line which now churns out 1,250 automobiles a day.

Right:
The old centre of Landau, founded in 1224 by Duke Ludwig of Kelheim, perches atop a hill up above the River Isar. The foundations of the parish church also date back to this period; the place of worship was later baroqueified to become a local landmark.

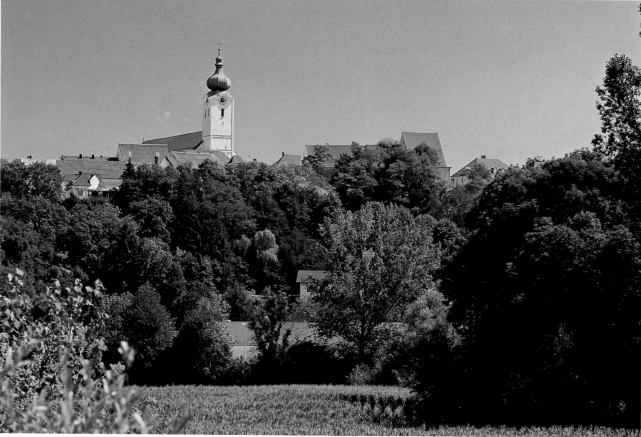

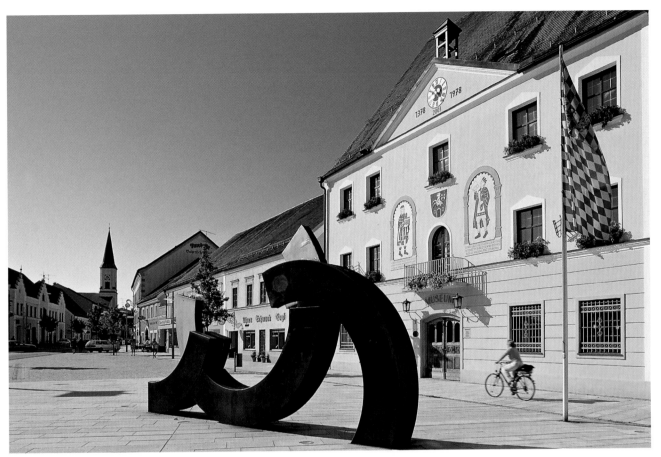

Left:
On the occasion of its 625th anniversary in 2003 Osterhofen in the Danube Valley had much work done on it, including the redesign of its market place in front of the Rathaus and museum.

Below:
The parish church of St Margaretha in Osterhofen-Altenmarkt is an absolute gem of the Rococo period, its exterior barely preparing visitors for the swirling delights which await them inside. The Asam brothers carried out their commission here to perfection, with Egid Quirin masterminding the sculpture and stucco and Cosmas Damian responsible for the frescoes and paintings.

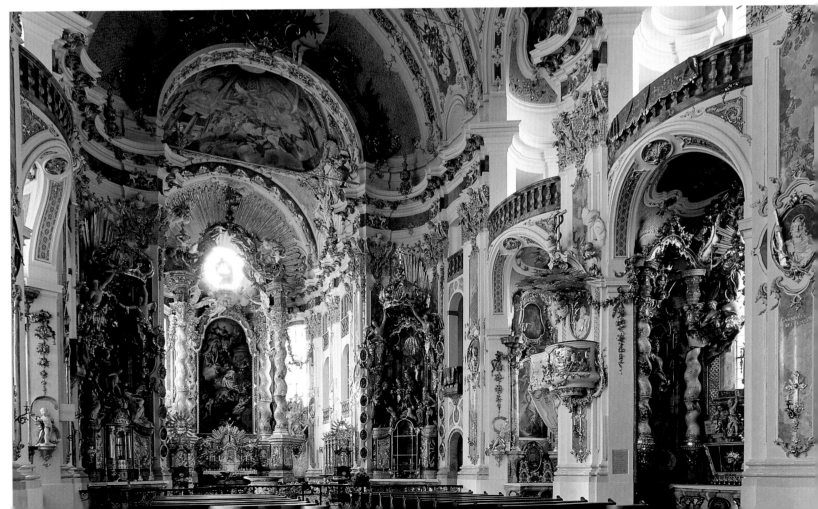

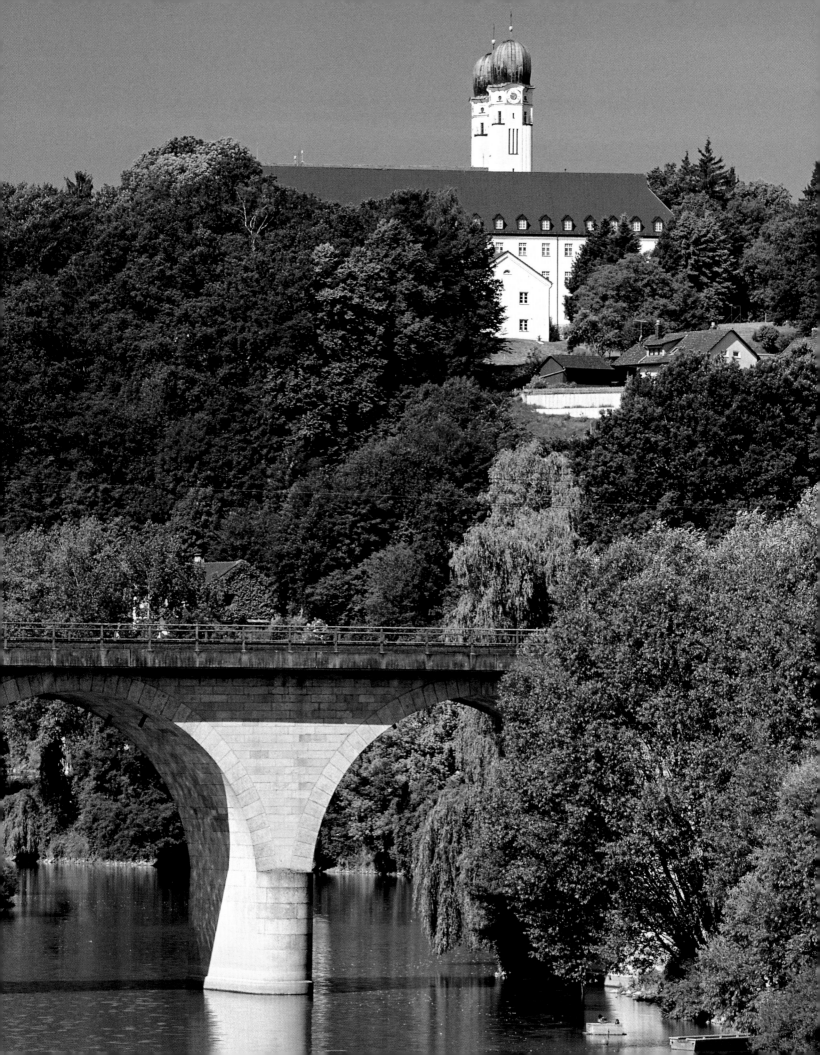

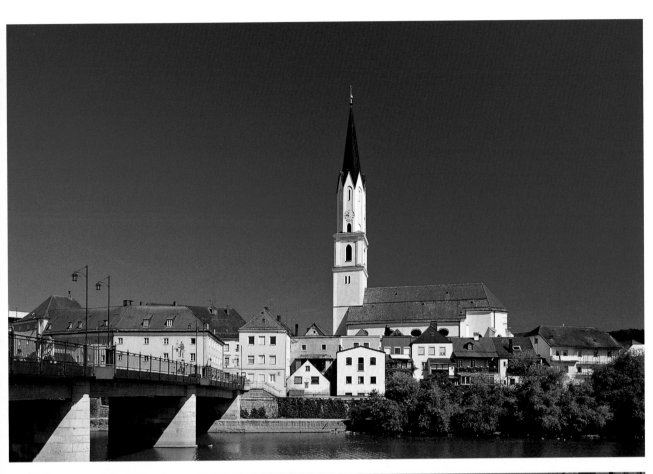

Its twin onion domes make it look baroque; the founding of the monastery of Schweikl-berg only goes back a hundred years or so, however. Benedictine missionaries settled high up above the rivers of the Vils and Danube here in 1904.

Vilshofen's Bajuvari roots date back to the 8th century. Situated on the three rivers of the Vils, Wolfach and Danube, Emperor Ludwig the Bavarian granted Vilshofen its town charter in 1345.

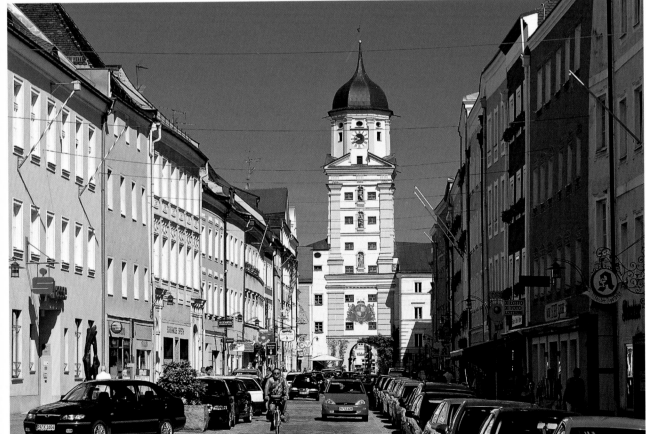

Politicians need an audience which is why on Ash Wednesday 1893 the traditional cattle market in Vilshofen began to be used as a forum for a motley crew of political parties and individuals. Political Ash Wednesday has since become a fixed event on the Lower Bavarian agenda and a focus of attention all over Germany.

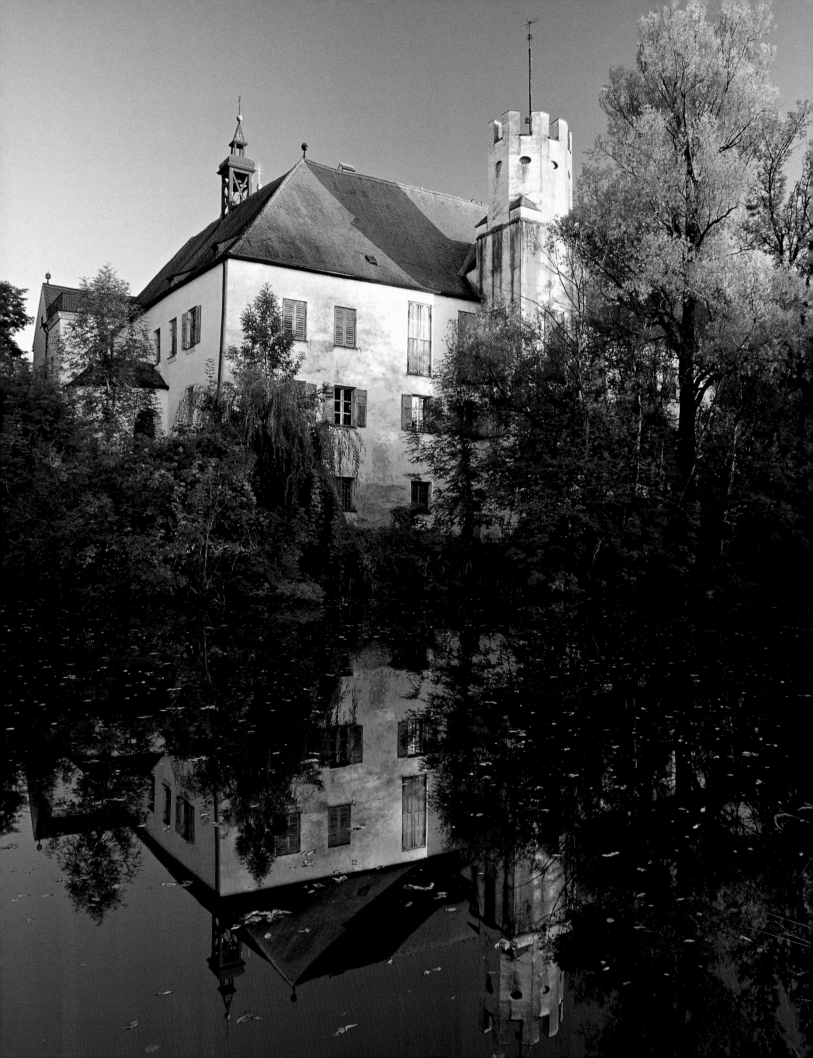

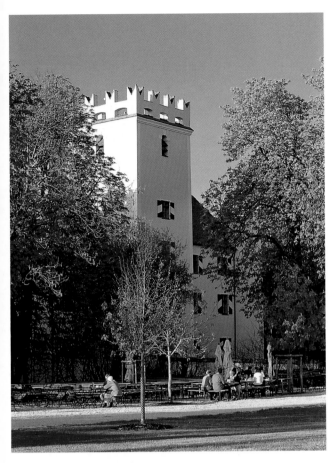

Far left:
It was to the Renaissance the architects of the moated palace of Mariakirchen looked for inspiration in the mid 16th century. The purely decorative battlements were added by later Historicist builders with a passion for all things medieval.

Left:
Church artist Georg Haberland ordered his architect to build him a fine house in the style of the Gothic period when in 1870 he decided to settle on Stadtplatz in Eggenfelden. Despite its fake Historicism his abode has stood the test of time and still looks resplendent today.

Left page:
It's thought that Arnstorf in the Rittal could have got its name from the archbishop of Salzburg, Arn (c. 740–821). Its palaces can be traced back to the imperial counts of Closen. The Oberes Schloss still has its moat, dug when it was built between the 15th and 17th centuries.

Far left:
There are many idyllic spots in the district of Rottal-Inn, such as the Rahmühle near Ering, depicted here.

Left:
The onion domes of Gartlberg were added to the parish church in 1715. On the occasion of an alleged miracle in 1660 the image of the Suffering Virgin drew pilgrims in their thousands, making a larger church necessary.

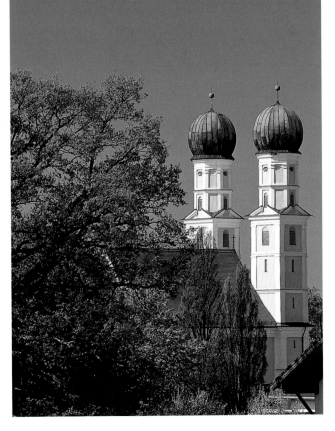

Aquick look at the calendar of events clearly reveals that party management in Catholic Lower Bavaria is definitely the prerogative of the region's veritable host of religious patrons. St Leonard is the biggest of them all: patron saint of carriers, blacksmiths and stablehands, of cattle and horses, and also responsible for a whole bevy of festive farming activities. November 6, the feast day of "God of Bavaria" as he has come to be known, is associated with a diverse array of customs and traditions. One of these is the *Leonhardiritt* or procession on horseback, where ornately decorated steeds and stallions from Rottal to the Bavarian Forest partake in open-air services where they are solemnly blessed. In some areas the occasion takes on an even greater sense of ceremony – and merriment – on the involvement of *Würdinger-Schutzen*, votive statues of iron people and animals which are offered up to St Leonard in thanks. The fun really starts when the village lads begin tossing the massive figures around in a test of strength undoubtedly fuelled by copious amounts of beer.

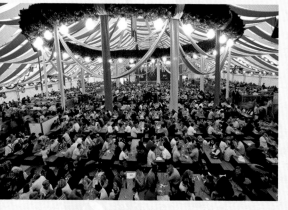

In Sankt Englmar in the Bavarian Forest the local saint pulls the crowds every Whitsun at the traditional *Englmarisuchen*. Dressed as hunters, labourers and nobles from the late 19th century, the men of the village ride up to the chapel mount on horseback where they begin searching for a body – that of the hermit St Englmar who was allegedly beaten to death by jealous companions during the 12th century. Once "rescued" the saint is carefully laid out on an ox-drawn cart and returned to the church amid much reverence and revelry – after mass has been attended outside in the lush spring fields.

The *Englmari* parade has been joined by the *Pfingstl* in recent years – although the latter has nothing to do with the canonised martyr.

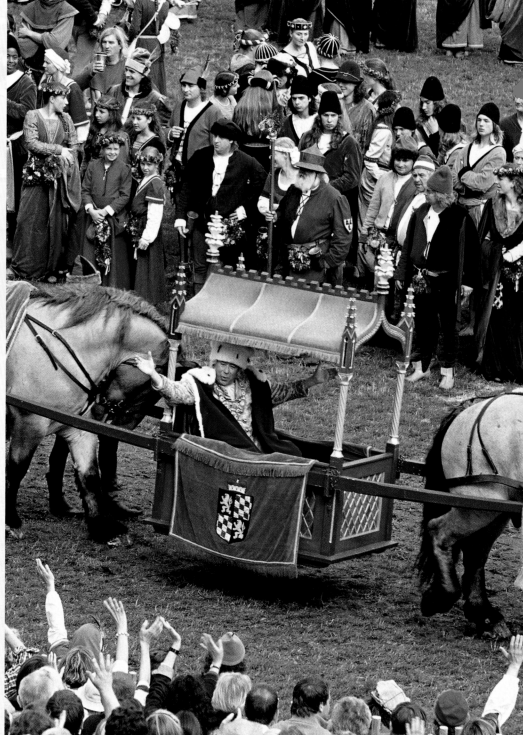

Left:
Candy floss and sausage, heart-stopping rides and the inevitable beer tents pull the crowds at the Gäubodenfest in Straubing every August.

Above:
The Landshut Wedding of 1475. After the colourful parade through town the wedding guests arrive at the tournament where they watch medieval entertainers juggling and knights jousting.

Top right:
"Würdinger-Schutzen" is an old tradition upheld in Aigen am Inn, where votive iron statues are tossed around in a test of strength.

Top right:
The volleys fired by blue-coated soldiers at the Pandurenfest in Spiegelau are harmless and all part of the general spectacle which marks the events of the Spanish War of Succession.

FESTIVALS IN LOWER BAVARIA

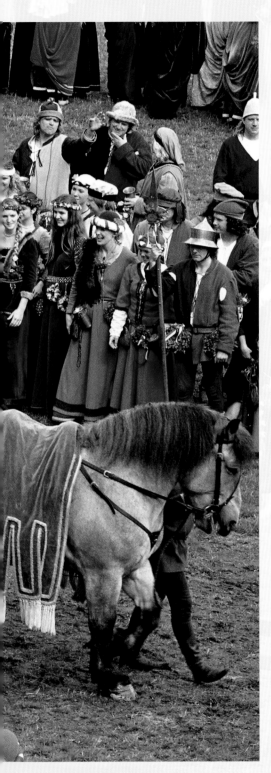

The *Pfingstl*, who closely resembles a walking fir tree, is a remnant of the ancient fertility cult of Grüner Georg. Green has long been associated with fertility, prompting the *Pfingstl* and his band of merry men to go from house to house quoting silly verse for which they customarily receive small gifts. A similar Whit tradition is upheld by the *Wasservögelsinger* ("waterfowl singers") of the middle and lower Bavarian Forest – except here the would-be warblers can expect to be showered with buckets of water (a symbol of fertility) instead of presents. The "mob" thus prudently dons an assortment of macs before daring to utter a note: the singers, the *Eierkater* who collects the eggs traditionally proffered as a reward and the *Kirmträger* who carries the eggs in a basket on his back. On their return to the village pub the damp choristers continue to sing for their supper and are rewarded for their pains with round upon round of free drinks – undoubtedly until the small hours of the next morning.

FESTIVE TRADITIONS

Beer is naturally also of great importance at the second biggest public festival in Bavaria. In August 2007 no less than 1.2 million visitors flocked to the eleven-day Gäubodenfest in Straubing. The festival goes back to King Max Joseph I, who in 1812 allowed an agricultural fair and stud show to take place in thanks for the high yields of the fertile Gäuboden. Like Munich's Oktoberfest the market soon became a popular local event, now complete with beer tents, funfair rides and foreign visitors.

Landshut celebrates itself when every four years the wedding of George, son of Wittelsbach duke Ludwig the Rich, to Polish princess Jadwiga Jagiellon is staged. Magnificent parades through the old town, peaceful camps on the banks of the Isar and medieval tournaments against the impressive backdrop of Burg Trausnitz all mark the joyous affair of 1475. Many of the locals dress up for the occasion, slipping into painstakingly fashioned historic costume and re-enacting the life of the good burghers of 15th-century Landshut under the auspices of the duke and his entourage.

A less exuberant episode in the history of the Bavarian Forest during the mid-18th century is commemorated by the Pandurenfest in Spiegelau. In 1741 Baron Franz von der Trenck began mustering a volunteer army of 1,000 to fight for Maria Theresa in the Austrian War of Succession – in other words, he and his men plundered and pillaged their way east through a terrified Bavaria. In Spiegelau in the Zwieseler

Winkel he blackmailed the mayor into handing over the parish coffers, undoubtedly uttering the famous demand: "Your money or your life". Today neither are in any danger when (harmless) rounds of gunpowder are fired up into the air in celebration. At the Säumerfest in Grafenau the gallop of horse hooves excites the crowds when the salt merchants of Haselberg come thundering into the little town. Each year at the beginning of August Grafenau puts on its historic festival in memory of the major role the salt trade once played in the area.

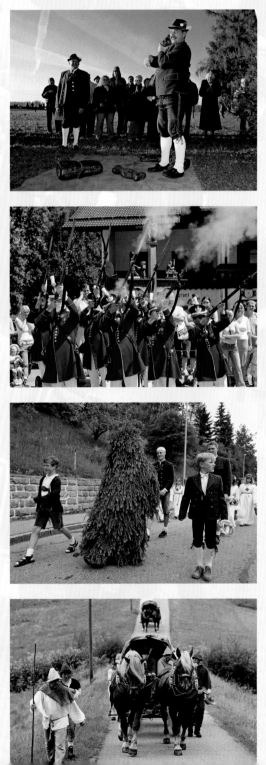

Center right:
Folklore meets religion when at Whitsun the "Pfingstl" joins the church procession in Sankt Englmar. The pine tree is a Celtic fertility symbol, the "Englmarisuchen" an declaration of Christian faith.

Bottom right:
A nocturnal camp and celebratory procession mark the start of the yearly Säumerfest in Grafenau, where the locals dress up as salt traders in deference to the town's lucrative past.

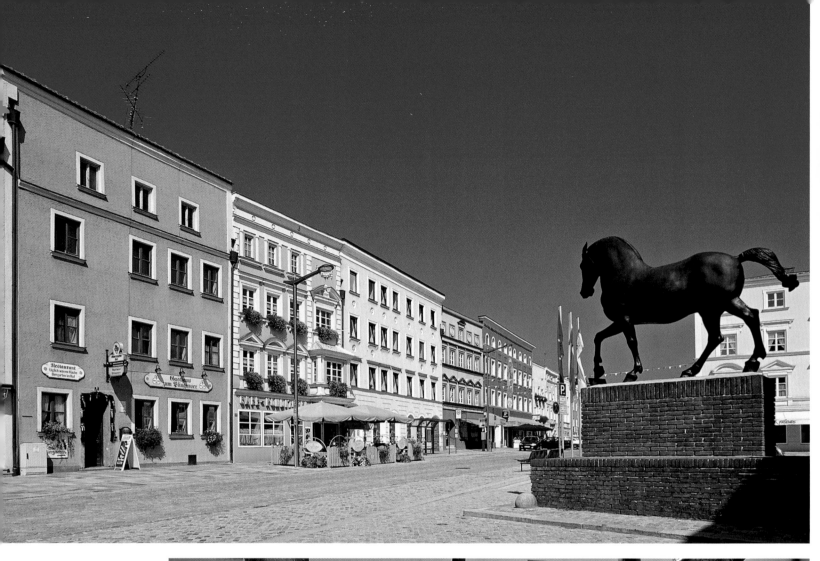

Above:
The horse statue which adorns Stadtplatz in Pfarrkirchen pays homage to the long tradition of horse breeding here in the Rottal. It was donated by artist, professor and keen rider Hans Wimmer in 1966. The square is surrounded by houses with blind facades, traditional for the towns along the Inn and Salzach rivers.

Right:
If you look closely there's also a horse on the fountain in Pfarrkirchen, designed by Joseph Neustifter in 1990. Mary and the Baby Jesus are protected by five arches whose pillars depict the patron saints of the town's five churches.

The European nature reserve of the Unterer Inn stretches from the confluence of the Salzach and Inn to the River Rott. Expanses of wooded meadow and barely accessible reaches of the river make this area in both Germany and Austria an important place of refuge for an extraordinarily diverse range of plants and animals. Despite the serenity of places such as the Inn reservoir near Ering (left), people are also welcome here, with various relaxing activities on offer (boats at Mühlau near Simbach, below).

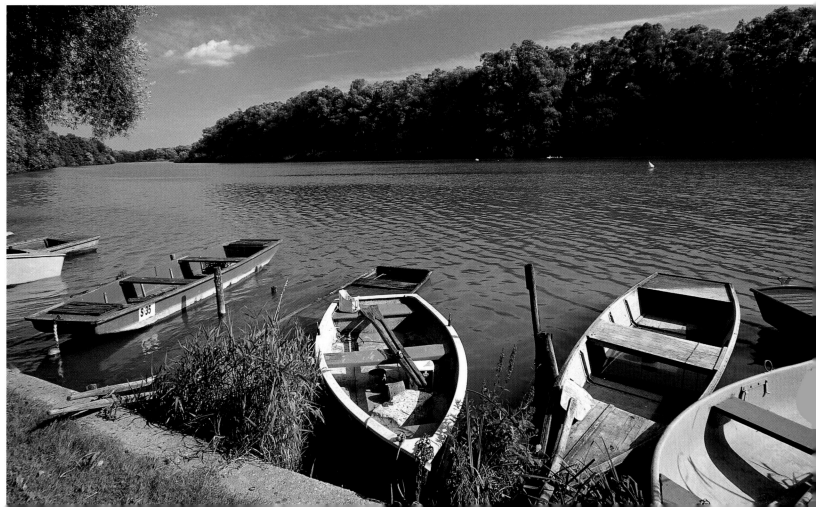

Right:
The "growing rock" near Usterling rises one to two millimetres a year. This natural phenomenon is explained by the linear deposit of chalk. Carbon dioxide in spring water absorbs chalk when it passes through layers of rock; when this water trickles over moss, the moss absorbs the carbon dioxide and a chalk deposit remains.

Below:
Along its lower reaches – here at Kröhstorf near Eichendorf – the Vils is dreamy and romantic, with trees lazily dipping their branches into the cool water.

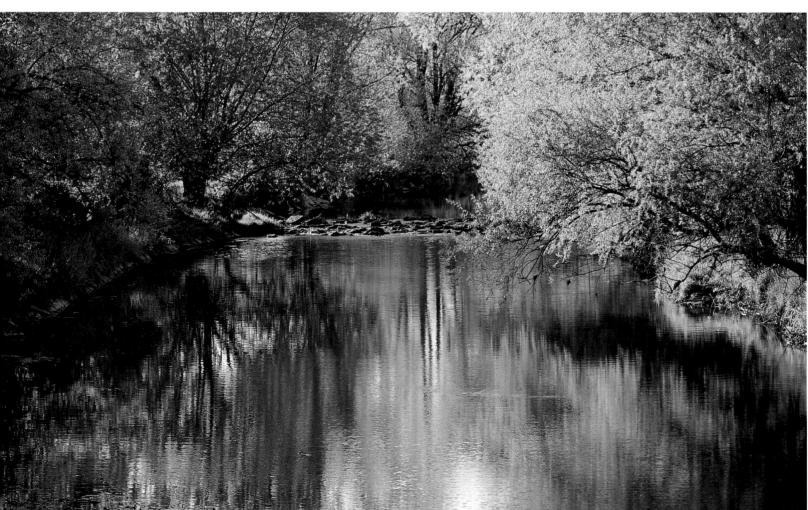

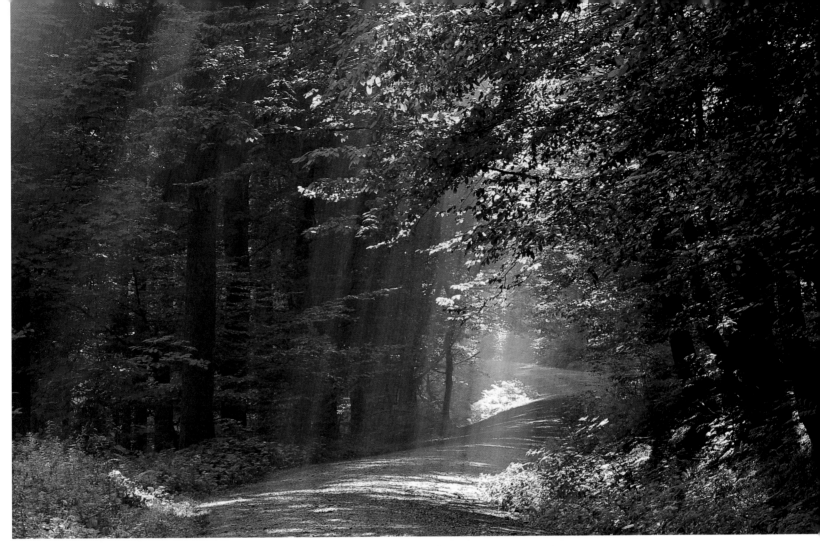

The waters of Bad Griesbach are just one of the keys to the spa's great success; Griesbach was famous for its good, clean air long before thermal springs were discovered here. This halcyon leafy trail leads through the forest to the Teufelsfelsen or Devil's Rock (left). Legend has it that Satan once planned to destroy the village with the giant boulder but abandoned it in haste when he heard the church bells ringing.

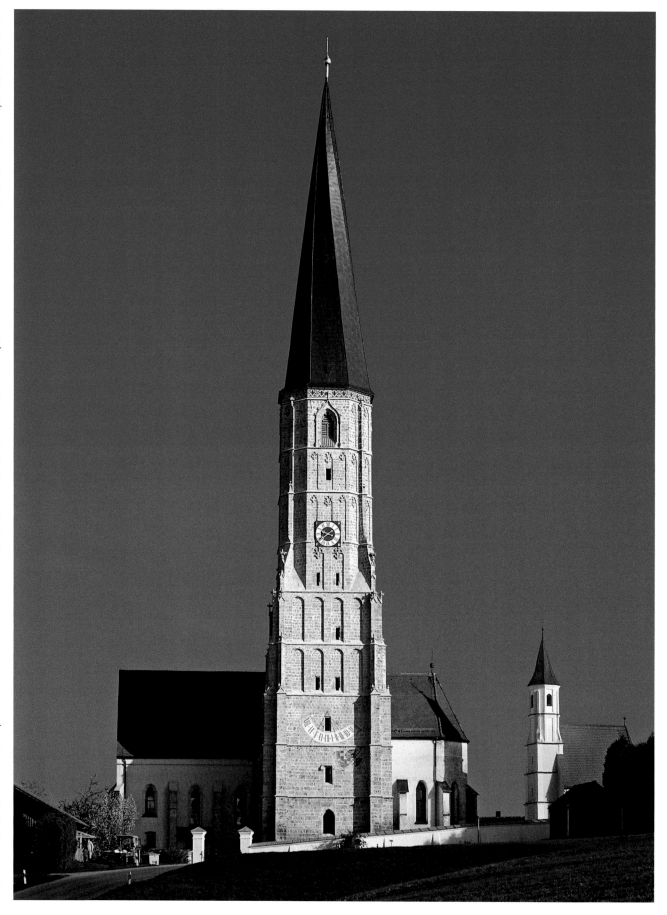

Top right page:
The Benedictine monastery of Asbach in the lower valley of the River Rott is nothing less than imposing. Little is left to remind us of its original 11th-century fabric since François Cuvilliés the Younger began refurbishing the complex in late Rococo in 1770.

Right:
The Gothic steeple of St Ägidius in Schildthurn from 1530 seems out of all proportion with the buildings it dwarfs. There's a good reason for it; its size signifies the importance of pilgrimage to this holy place, where the faithful pray to the virgins Einbeth, Wilbeth and Warbeth and to St Leonard, the patron saint of farmers and livestock.

Bottom right page:
This late Gothic pilgrim-age church in the unassuming little village of Grongörgen in the Rottal is a surprising find. Dedicated to saints Gregory and Leonard, the stained glass on the north side of the nave and chancel is attributed to master artists from Landshut, installed soon after building was completed in the 15th century.

70

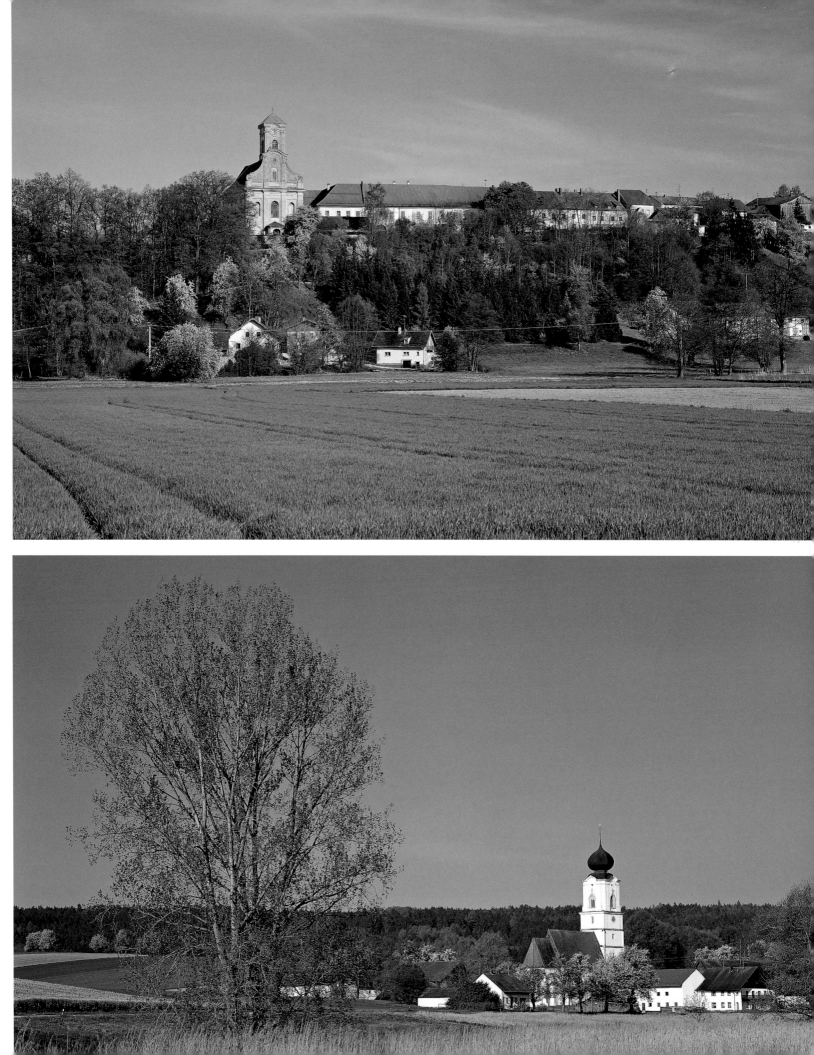

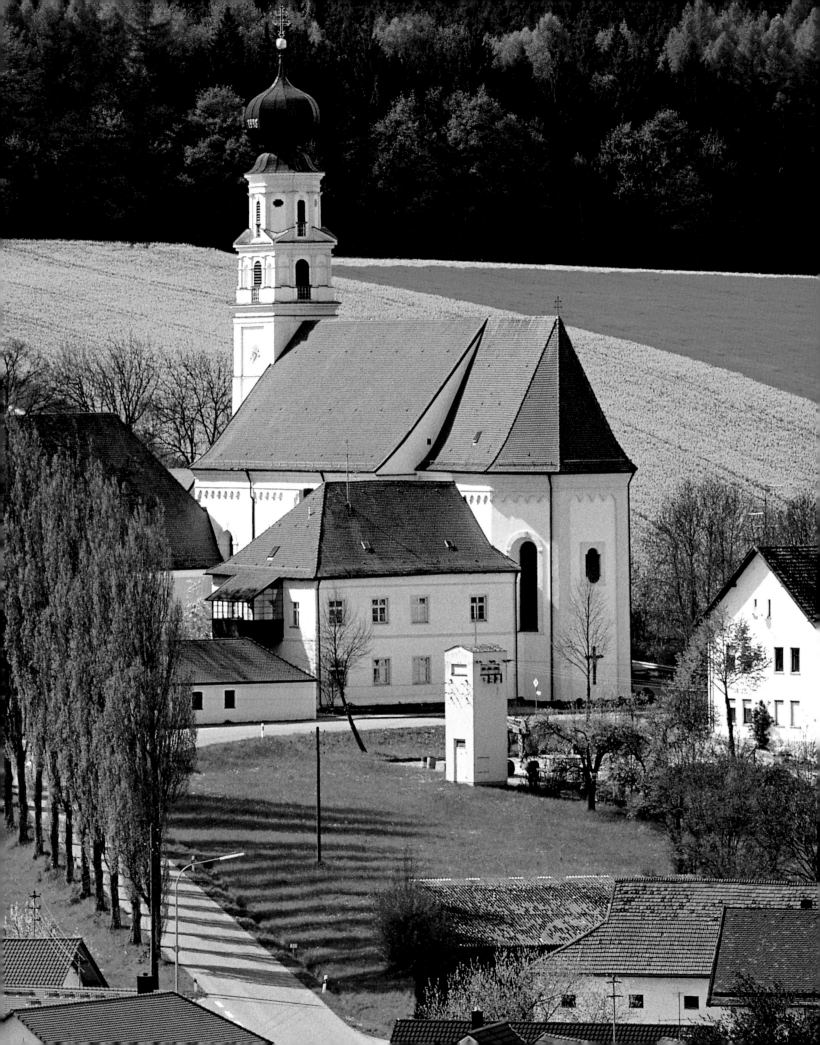

Page 72/73:
Kloster St Salvator near Bad Griesbach lies embedded in an idyllic, gently undulating landscape. Even while the Thirty Years' War was still raging Bartolomeo Viscardi began rebuilding the burnt down Premonstratensian monastery and turning it into a masterpiece of the baroque. The complex now offers tasteful holiday accommodation to guests from far and wide.

Below:
Burg Griesbach first appears in the annals of a Passau monastery in the 11th century. It was the seat of a court and tax office and of their modern successors until the reforms of 1972. One year later the discovery of a new thermal spring catapulted the town into the limelight as a top German spa.

Top right:
Looking south from Bad Griesbach you can see as far as Karpfham. The sleepy little village comes

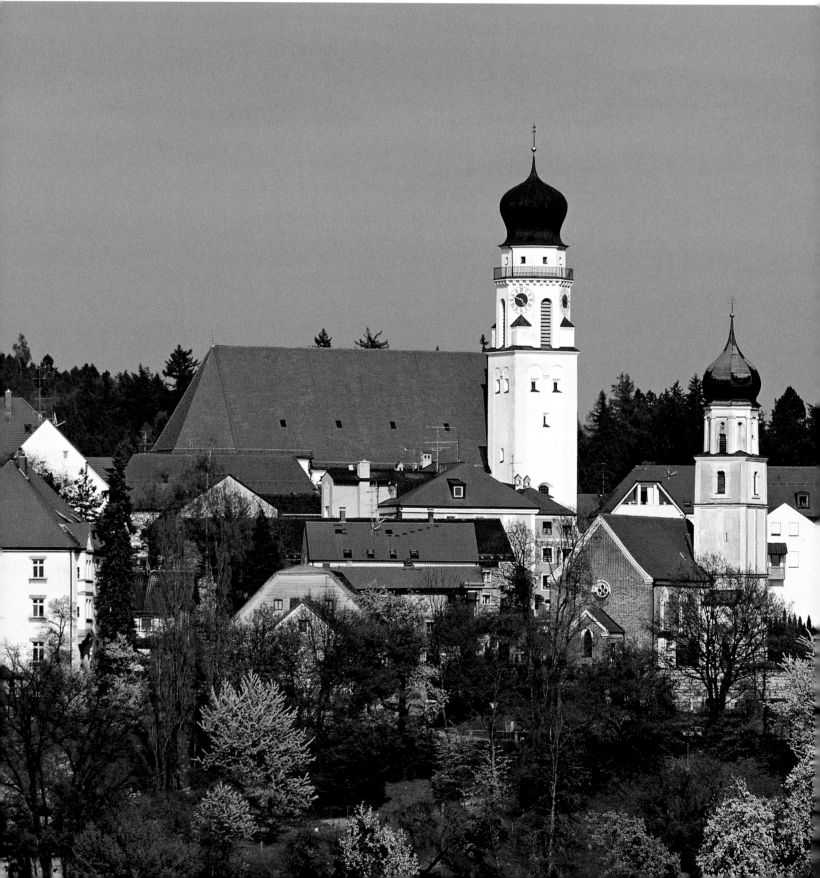

alive with a vengeance once a year when a horse jumping tournament and fair take up residence for a few days.

Centre right:
The hot mineral springs which bubble into the spa of Bad Griesbach have a temperature of 60°C.

Bottom right:
Bad Griesbach is one of the biggest golfing centres in the world. It's also one of the most scenic, with fairways and greens tucked into a pleasant country landscape.

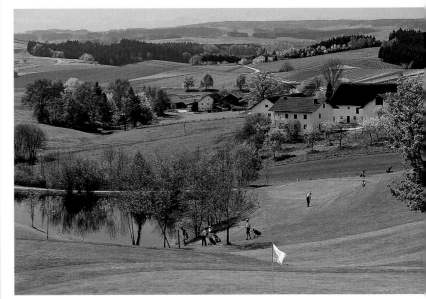

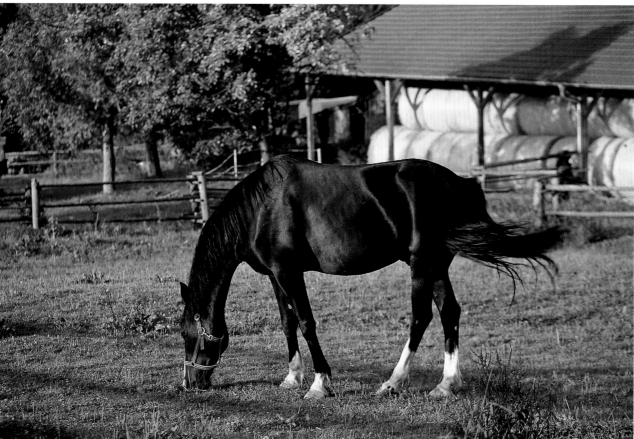

The valley of the River Rott is old farming country. Horses were introduced by the Romans yet it was Duke Albrecht V who initiated their actual breeding. In 1559 he had carefully selected studs taken to local manors so that suitable mounts could be bred for the cavalry. The typical Rottaler, a middle-weight yet strong draft and carriage horse, was first developed in the 19th century.

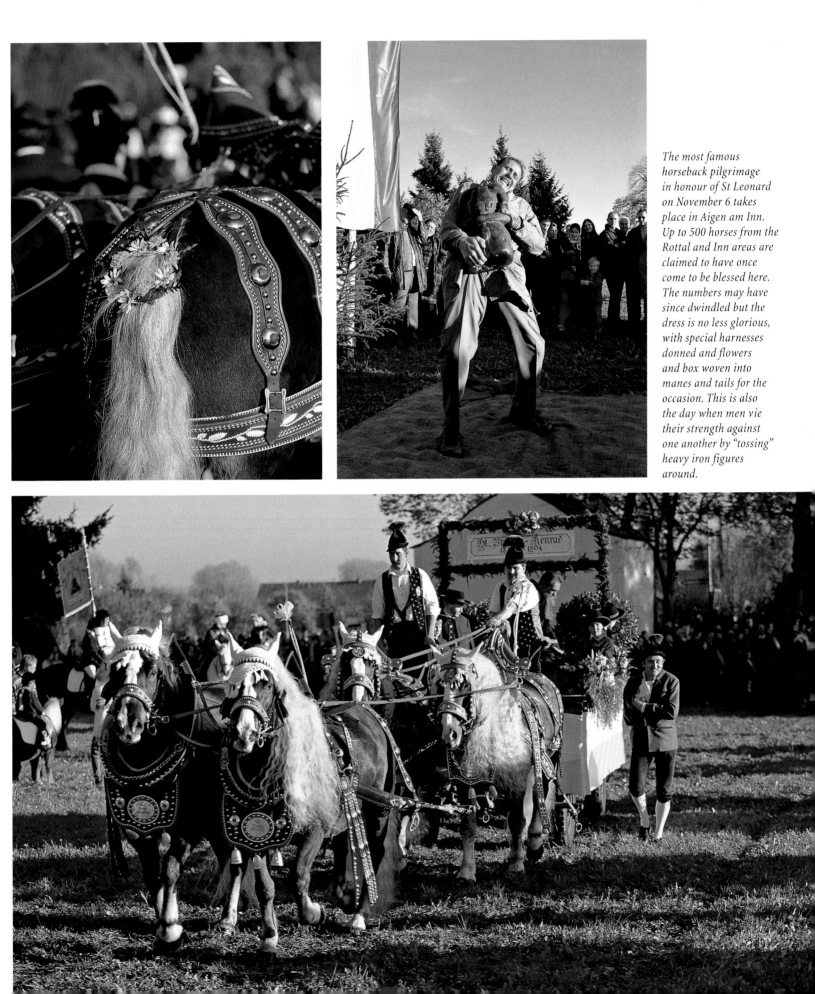

The most famous horseback pilgrimage in honour of St Leonard on November 6 takes place in Aigen am Inn. Up to 500 horses from the Rottal and Inn areas are claimed to have once come to be blessed here. The numbers may have since dwindled but the dress is no less glorious, with special harnesses donned and flowers and box woven into manes and tails for the occasion. This is also the day when men vie their strength against one another by "tossing" heavy iron figures around.

Below:
In Bad Birnbach, the second in the trilogy of Lower Bavarian health resorts, the parish church is still the local landmark – despite the new wellness temples which have sprung up round about. The entire town operates on the principle of the modern "country spa".

Photos, right:
Birnbach has been a recognised spa since 1987 with the Chrysanti spring reaching temperatures of 70°C. This services the 23 warm pools of the Rottal Therme baths. Its healing properties are beneficial to degenerative and rheumatic illnesses of the joints and can be enjoyed in an atmosphere which is both relaxing and extremely pleasant.

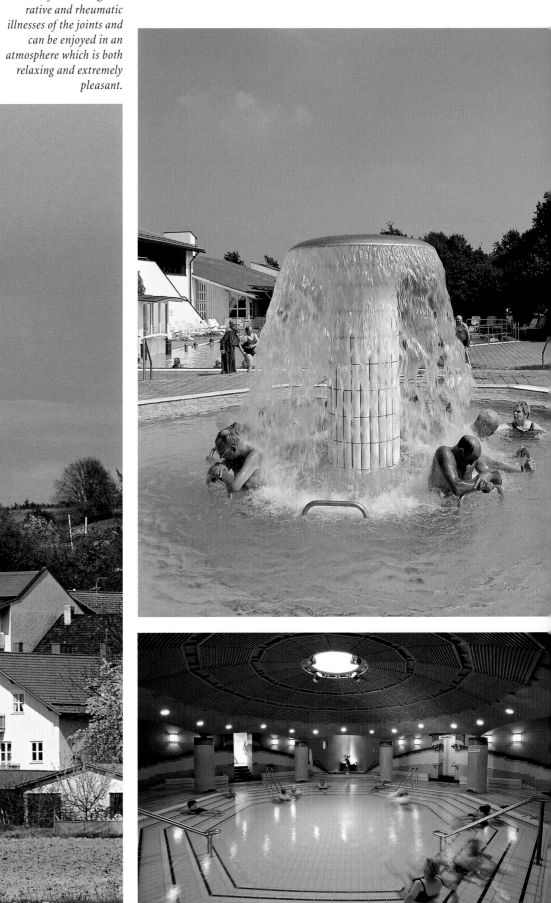

Right:
Lower Bavaria's career as a health resort began in Bad Füssing when in 1939 workmen struck not oil but "just" a hot mineral spring 927 m (3,040 ft) underground. A private clinic opened here in 1946 triggered a number of scientific investigations, prompting Füssing's conversion to a spa with all the mod cons, including parks, pools and plenty of punters.

Below:
If you fancy a break from splashing about in the pool you can hop on your bike and explore the many kilometres of (flat) cycle track tracing the contours of the River Inn.

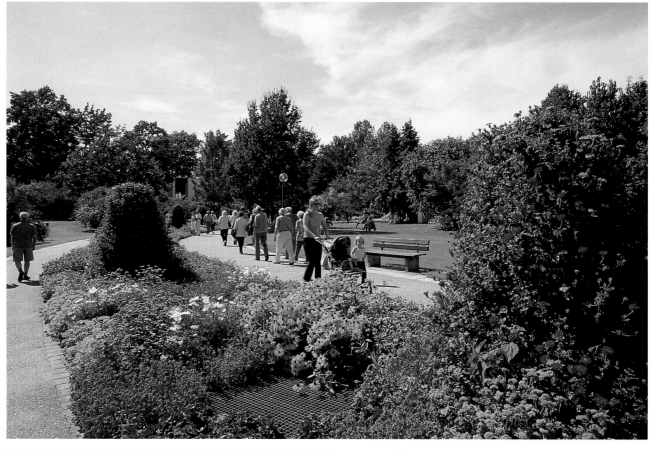

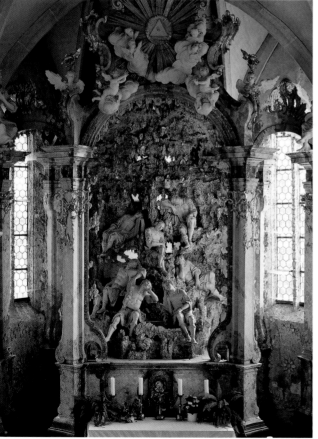

Above:
Schloss Kleeberg near Ruhstorf on the Rott, built in 1610, is a compact affair with four corner turrets.

Far left:
The high altar of the Siebenschläferkirche of Rotthof near Ruhstorf, built in 1758 by Johann Baptist Modler, is heralded as one of the best artistic portrayals of the Seven Sleepers of Ephesus who, it's said, fell asleep in the year 250 on being chased into a cave – and didn't wake up again until 437.

Left:
This bronze mare rolling in the dust on Kirchplatz in Pocking represents the town's past as a centre of the horse and cattle trade.

Right:
High above the market town of Ortenburg stands a 16th-century Renaissance palace with an atmospheric courtyard. Ornamental window frames and two-storey arcades give it a decidedly regal air.

Below:
Schloss Neuhaus on the left bank of the Inn has carefully scrutinised the river crossing at Schärding since the 14th century. Salt, grain and rafting helped the little town to fame and prosperity throughout the region during the Middle Ages.

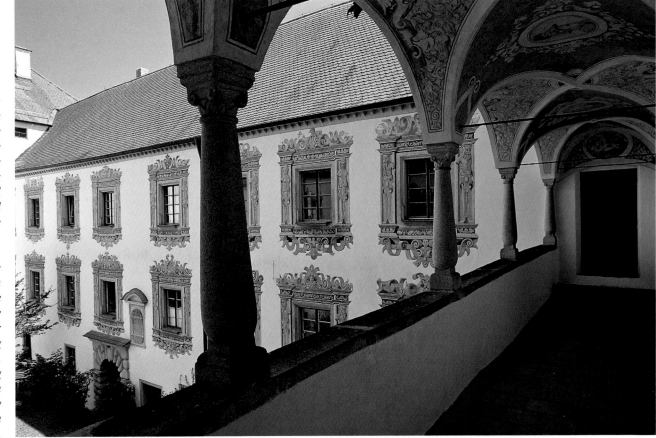

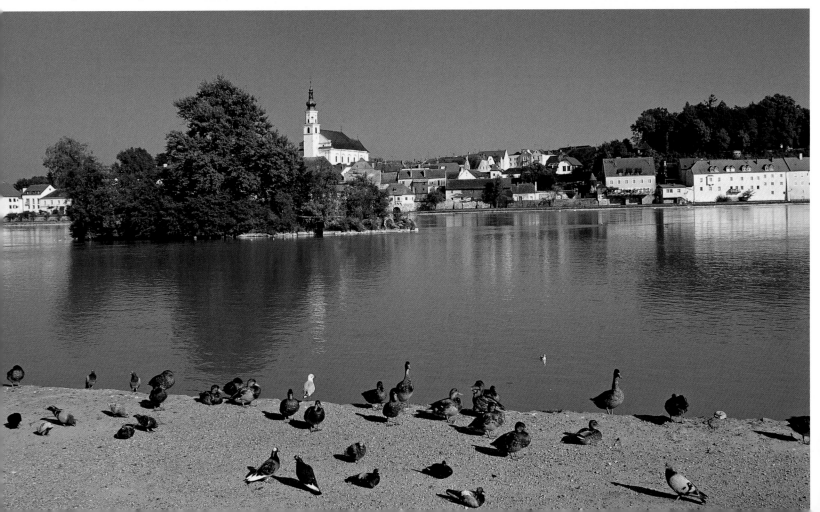

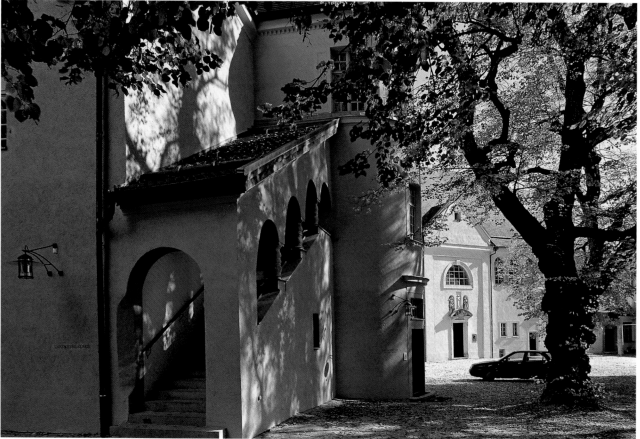

The towers of Neuburg
am Inn, once seat of
the counts of Vornbach,
now gleam benignly
in the sunshine where
once they bred terror
in the hearts of their
adversaries. The counts
began constructing
their mighty domicile
in 1040; behind the
rather bleak and
forbidding exterior is an
elegant early Renaissance
palace which now
heartily welcomes guests
to its four-star hotel,
conference centre and
tavern – the latter in
operation since 1440.

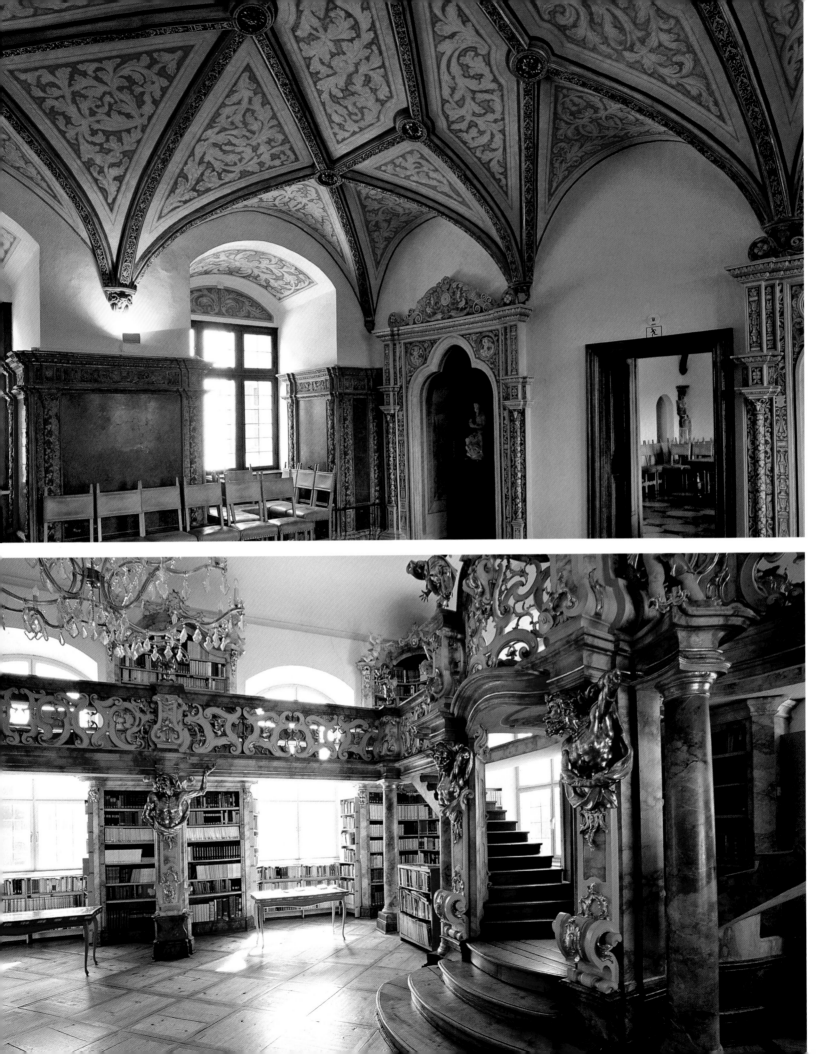

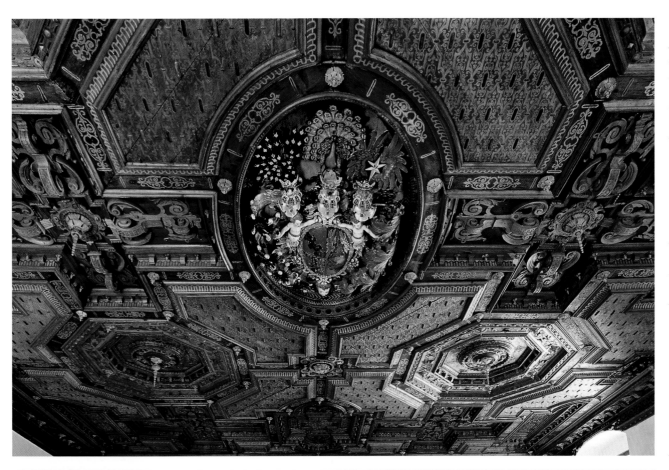

They drew their inspiration from far afield, from the fair lands south of the Alps where the Ancient World had once fired the creative minds of the Renaissance. Cosmas Damian (1686–1739) and Egid Quirin Asam (1692–1750) were also thinking of Italy when they composed their sensuous designs for sites of religious ritual, for churches in monasteries and for ambitious local parishes. The two brothers, one an architect and painter, the other a gifted sculptor and stucco plasterer, became the leading lights of the late baroque in South Germany.

The art treasures bequeathed by pre-Roman cultures thousands of years hence have only

been relatively recently unearthed by archaeologists. The reduced figure of the 6,000-year-old Venus of Aufhausen southeast of Landau is akin to the abstract sculptures of late Picasso. The ornamental swirls on Celtic jewellery and rough pottery are more austere than playful. Rome's attention was focussed on warding off attack from rebellious, warlike tribes and on supplying the many forts staking out the northern frontier of the Roman Empire. Finds from this period are thus primarily associated with the military, such as the unique face masks from dress uniforms and protective headgear for horses which are on display at the Gäubodenmuseum in Straubing. And even at the thermal springs of Gögging, frequented by the tired and dirty troops manning the limes, there is no hint of the luxury of the Roman baths the boys back home enjoyed.

In the centuries immediately before and after the turn of the first millennium AD chronicles report of the first Benedictine monasteries being founded, with buildings erected in the simple stylistic vein of the Romanesque. Scripts also record Hungarian offensives whose destruction necessitated the rapid construction of countless castles. Any feeling for art as such was thus first generated much later by the dynasty of the Wittelsbachs who had taken control of the duchy of Bavaria

in 1180. Their royal seat of Landshut flowered under the protection of its mighty fortress from 1204 onwards. In the mid-16th century the lords of the castle had a fashionable city residence created in the style of the Renaissance. In 1387 Landshut's clergy and citizens had begun erecting their own monument to power in the colossal Gothic hall church of St Martin's, commissioning famous artists such as Hans Leinberger with the interior design. Situated between the bishoprics of Freising, Regensburg and Passau, the giant brick building still smacks of the autonomy of the local nobility and townsfolk.

AN ARTISTIC BOOM

The first half of the 17th century has gone down in the annals of history as an age of terror. Epidemics of the plague and the plundering of the Thirty Years' War left the east of Bavaria – and many other places – on the verge of ruin. It's thus all the more surprising that the region experienced an artistic boom very shortly afterwards. The Bavaria of the Wittelsbachs – Catholic by ducal decree since 1555, with the exception of Protestant Ortenburg – was suddenly full of ardent pilgrims who readily donated funds for chapels and churches. A newfound joy of living was echoed in the furbishing of places of worship. Artists such as the Asam brothers, Dientzenhofer and Johann Michael Fischer (1692–1766) devised spaces both real (in brick and stone) and virtual (on canvas and plaster) for a veritable *theatrum sacrum*.

Where the nobility surrendered their titanic defences to the masterly exuberance of the baroque, sumptuous ballrooms evolved and

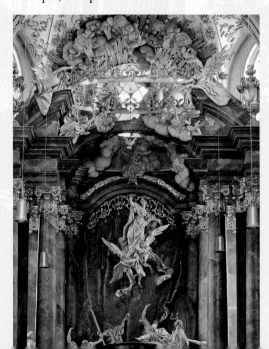

Far left:
The baroque grotto with its shell decor in the formal gardens of Schloss Neuburg am Inn is the work of Giovanni Battista Carlone.

Left:
The Ascension of the Virgin Mary has been formed to perfection by Egid Quirin Asam on the baroque altar of the abbey church of Rohr.

THE CREATIVE MINDS OF LOWER BAVARIA

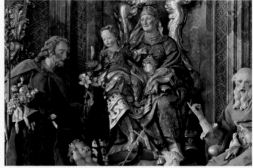

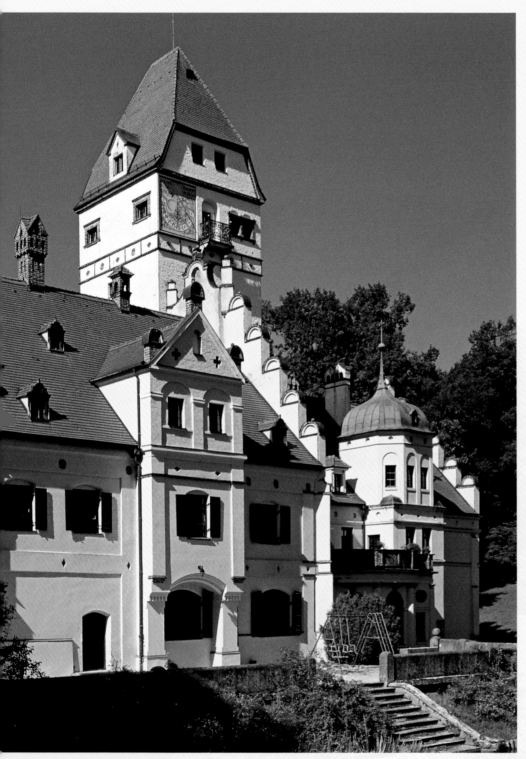

romantic grottoes and pavilions appeared in palace gardens, such as at Neuburg am Inn. A profane interest in ornamentation and detail was again expressed at the turn of the 19th century when Historicism exploded in its many guises: occasionally medieval, occasionally Renaissance, as the king of the castle required.

The names of contemporary artists from Lower Bavaria are cited at many international sites of renown – including the destroyed World Trade Center in New York. From 1967 to 1972 Fritz König made a bronze sculpture for the fountains beneath the twin towers. Terribly damaged, *The Sphere* was rescued from the ruins of 9/11 and installed in Battery Park as a monument to the terrorist attack of 2001. Born in Würzburg in Lower Franconia in 1924, the sculptor has lived and worked in Landshut (or not far from it in Ganslberg) since 1930. His extraordinary love of horses – he's not known as the pioneer breeder of Arabians in South Bavaria for nothing – is mirrored in many of his sculptures. The Landshut museum foundation devoted to his art is thus appropriate in its nomenclature: Arche Noah or Noah's Arc.

Above:
Water has protected the aristocratic seat of Schönau since the Middle Ages; the little castle only became a palace, however, at the Historicist hand of Munich architect Carl Jospeh Effner.

Top right:
The Premonstratensian collegiate church in Osterhofen-Altenmarkt, begun in 1726. On the right side altar fashioned by the Asam brothers it seems as if the holy family are in motion, with St Anne holding Mary and St Joachim standing beside her.

Right:
Hans Leinberger from Landshut betrays the influence of the Renaissance in his 1518 coloured wood carving of the Virgin Mary. The Madonna now adorns the right aisle of St Martin's in Landshut.

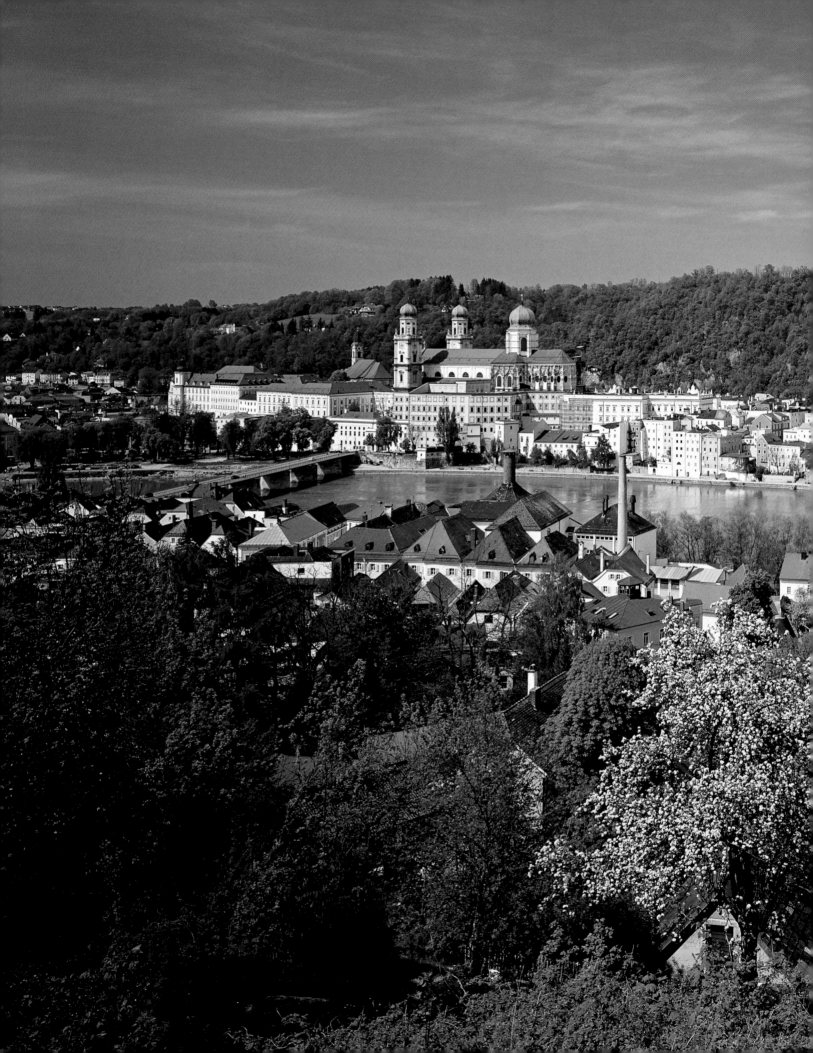

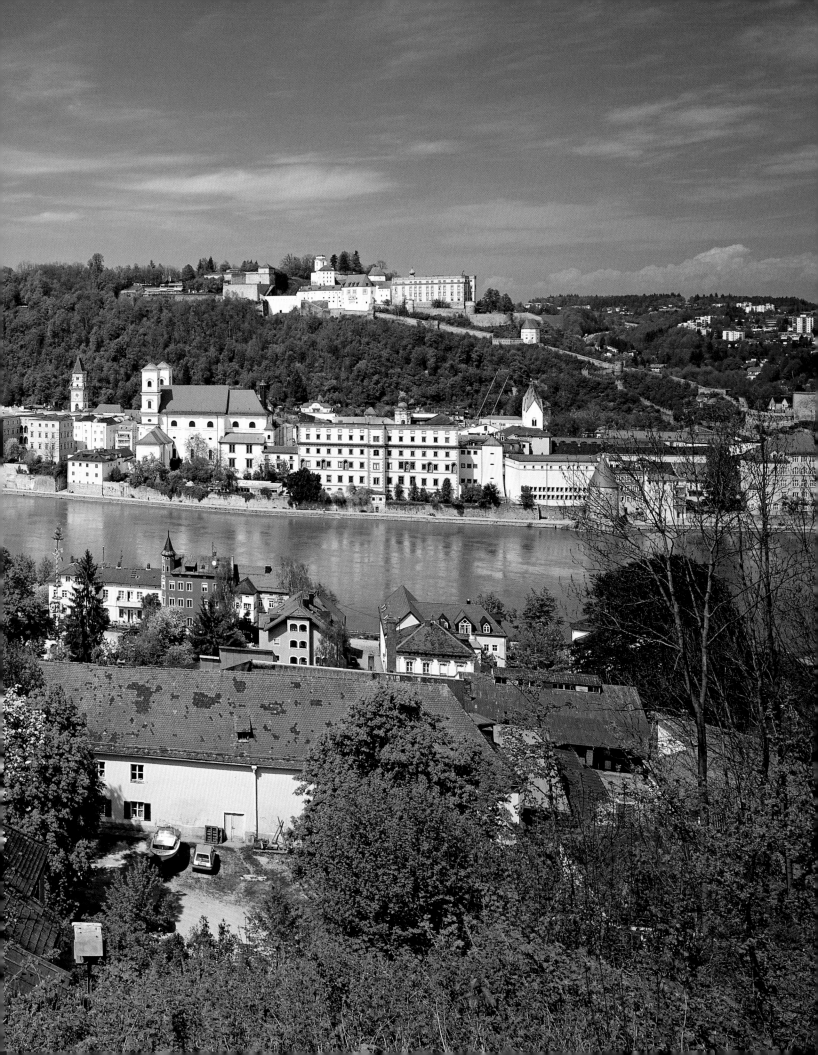

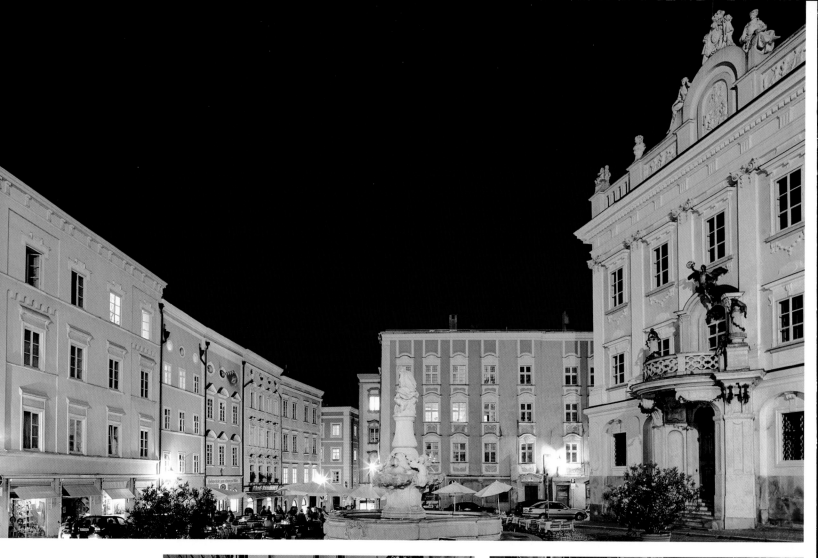

Above:

The Residenz in Passau next to the cathedral was where the clerical nobility held court. Passau became a prince-bishopric in 1217 and was the largest of its kind in the Holy Roman Empire.

Photos, right:

A charming labyrinth of narrow streets winds its way through the old heart of Passau between the Danube and the Inn. In 1662 a terrible fire reduced 80% of the city to ashes; the town was painstakingly rebuilt along the line of the old streets by Passau's wealthy civic and monastic communities.

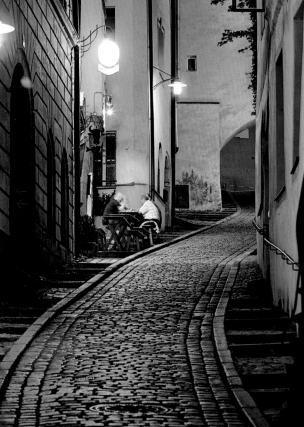

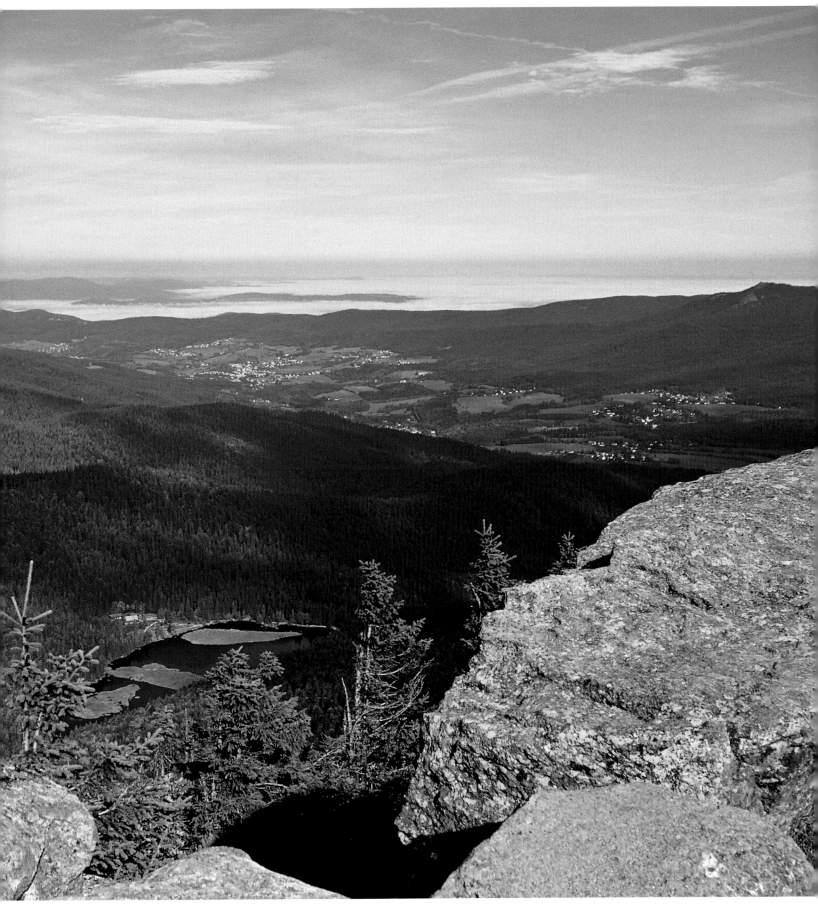

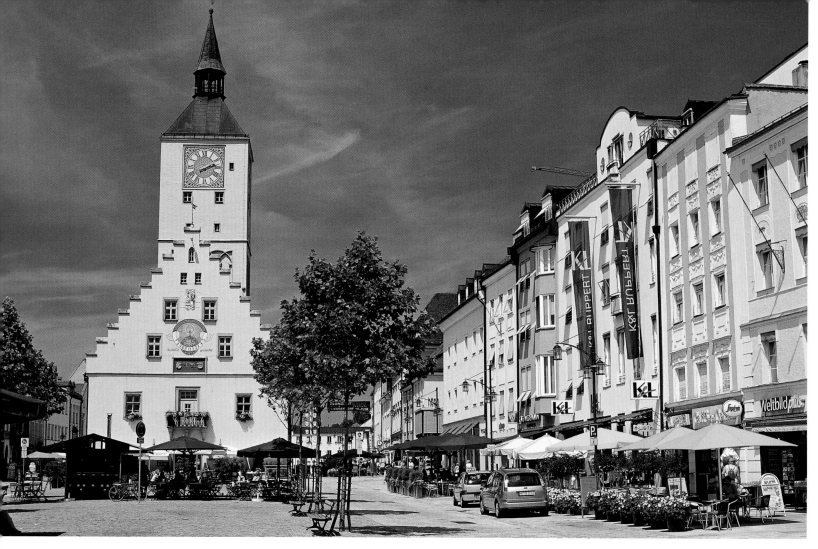

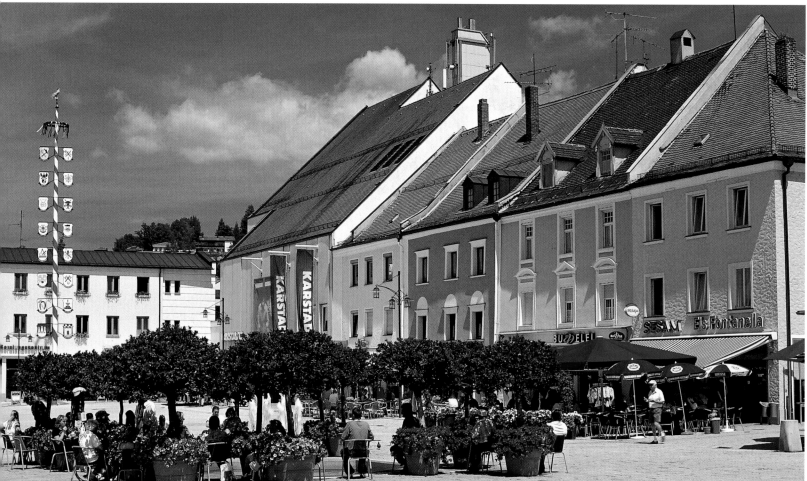

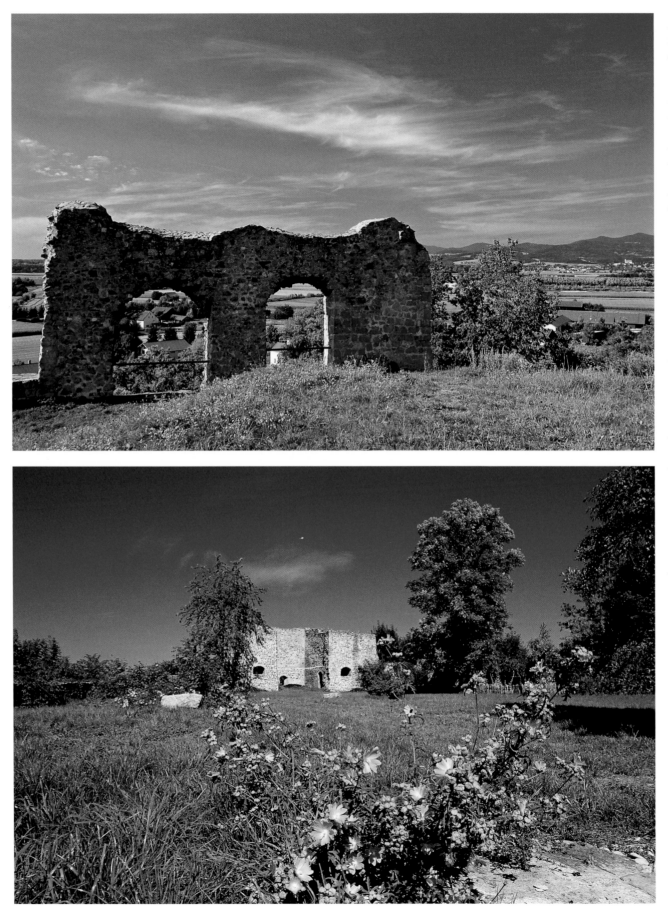

Masonry was steadily removed from the castle at Winzer, dynamited in 1744 during the Austrian War of Succession, to build the old Danube bridge at Vilshofen and various abodes in the surrounding villages. Its further demolition was only stopped by King Ludwig I of Bavaria slapping a preservation order on what was left of the ruins which date back to the 11th century.

Photos, left page:
The Danube was highly instrumental in the development of the trading post of Deggendorf, gateway to the Bavarian Forest. The generous proportions of Stadtplatz on either side of the Rathaus were designed to accommodate the town markets, still regularly held here. The Rathaus is from 1535, its tower a good 150 years older.

The castle of Natternberg is also in ruins, high up on the hill of the same name west of Deggendorf. During the 12th/13th centuries the influential counts of Bogen had the stronghold erected at this strategically prudent point which was first inhabited in the Neolithic Age.

Right:
The Benedictine abbey of Metten west of Deggendorf can look back on over 1,200 years of history. Famous artists, such as Cosmas Damian Asam, once worked on the sumptuous baroque interior of the Gothic church; with its 200,000 volumes the splendid library is no less superlative.

Below:
Schloss Egg has all the trimmings of a medieval fortress. This veritable knight's castle is, however, not what it seems; it dates back to a fairly recent 1840 when it was heavily restored. The curtain walls, the mighty tower and the great hall were given their "Gothic" visage during the heyday of the Romantic period.

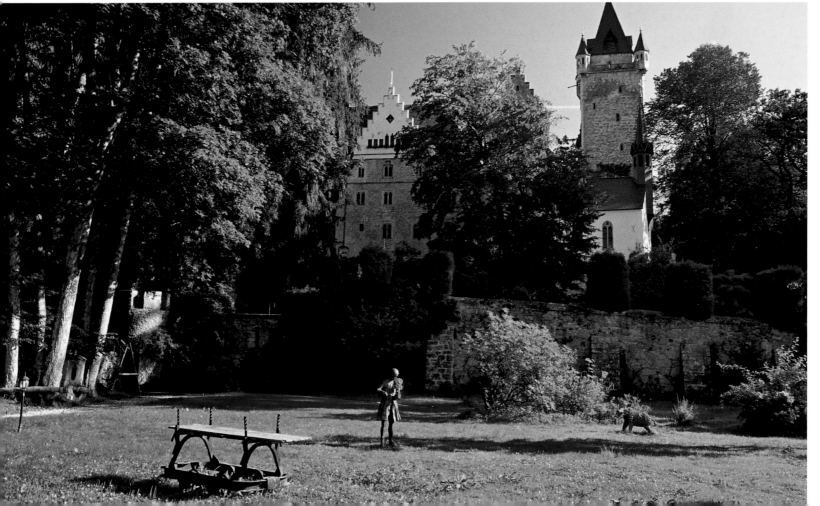

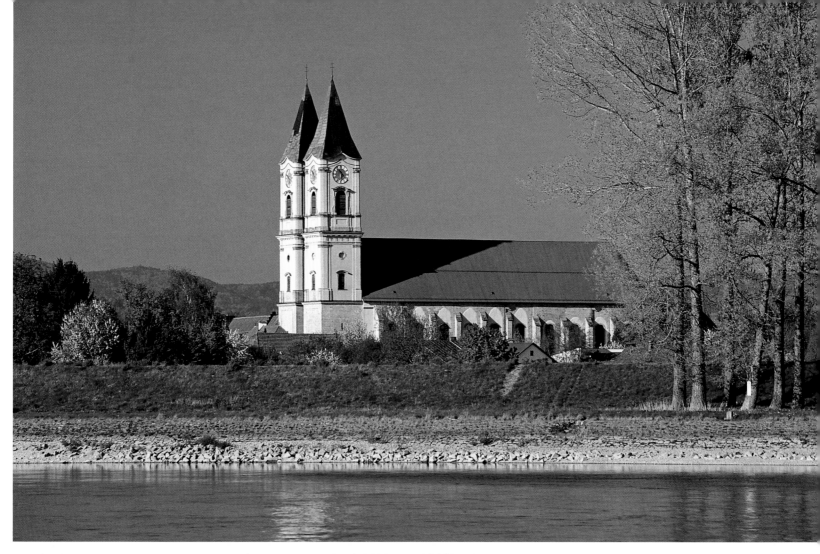

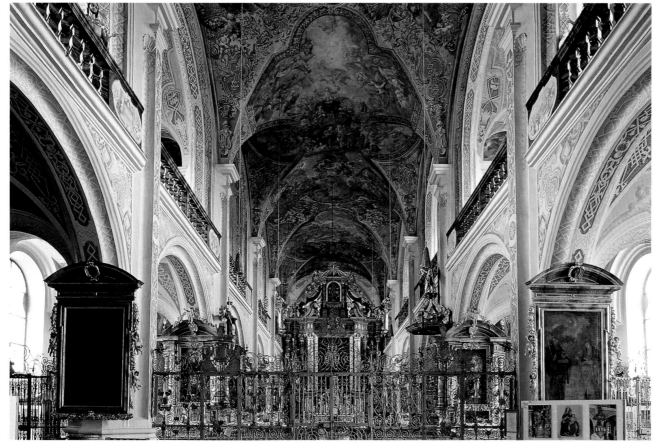

Above:
Wittelsbach coffers financed the building of the impressive hall church of Niederaltaich between 1260 and 1326, then one of the largest of its kind. Benedictine monks from Reichenau on the banks of the Danube first settled here in 741; the abbey later played a major part in the colonisation of Slavic territories.

Left:
Oberaltaich, not far from Bogen, was once a Benedictine monastery, dissolved during the secularisation of Germany at the turn of the 18th century. Its mighty Renaissance church, dedicated to Saints Peter and Paul, was refurbished during the baroque period.

Below:
Looking out across Teisnach, to the east you can see the gentle undulations of the Bavarian Forest whose unspoilt natural beauty is just waiting to be explored.

Top right:
Each year at Whitsun riders in historic costume head off into the forest for the "Englmarisuchen", a custom first recorded in the mid 19th century. It commemorates the terrible demise of a devout 12th-century hermit who was beaten to death by jealous comrades and buried in a makeshift grave in the woods.

Centre right:
A network of rocky woodland trails zigzags through the east of the Bavarian Forest National Park near the Kleine Kanzel. This is where the park is at its most aboriginal, with the roots of giant trees clinging to mighty boulders beneath a canopy of deep green.

Bottom right:
The perfect tonic for tired limbs after a long trek or cycle ride through the forest is a dip in the Teufelssee north of Viechtach.

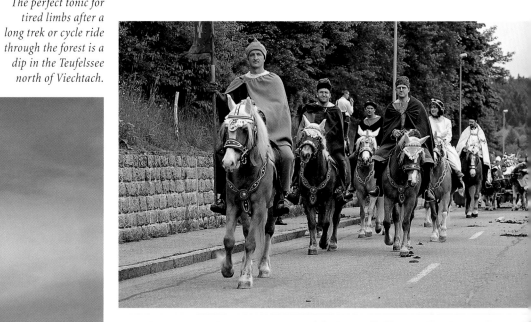

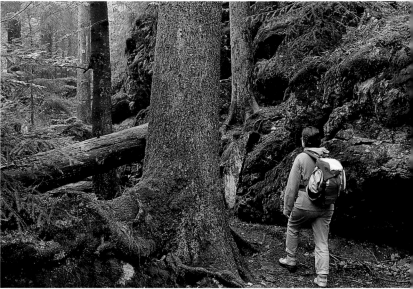

99

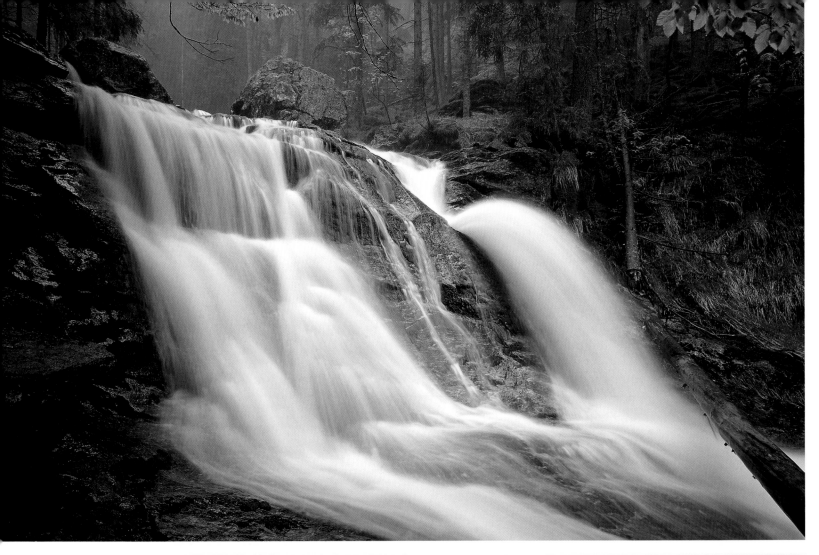

Between the Großer Arber and the Danube lies the Naturpark Bayerischer Wald, not to be confused with the higher-lying Bavarian Forest National Park. The rather damp climate encourages both a rich vegetation and the formation of many rivulets and streams. The highest of them, the Rißloch Falls (top), has a drop of up to 200 m (650 ft).

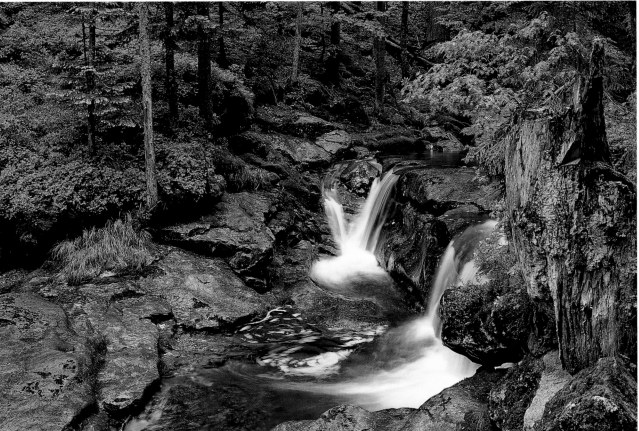

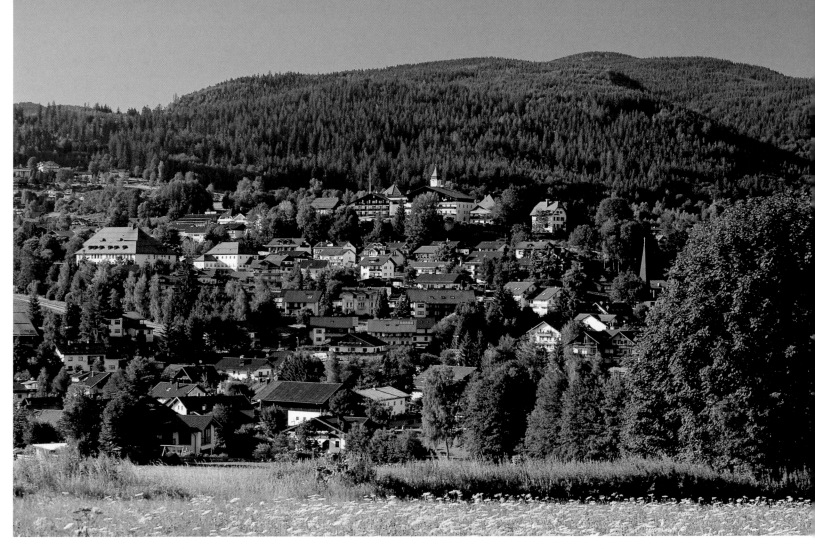

The health resort of Bodenmais (top) is the ideal place to set out from on hikes around the Großer Arber and the nature conservation area of Rißloch, opened in 1939. Bodenmais was once famous for its silver and rouge mines, the mixed woodland of Rißloch for the botanical rarities of alpine sow thistle and alpine snowbell.

Scholars deduce that glass – or the melting of it – was discovered rather by chance than as the result of prolonged scientific experiment. It is thought that in Mesopotamia and Ancient Egypt containers accidentally came in contact with quartz sand during the burning of clay or china, resulting in patches

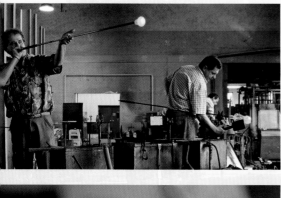

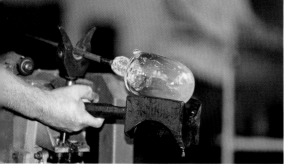

of glassy film appearing on their surface. By 1500 BC the Egyptians had worked out how to make hollow glass vessels by dipping a clay pot into a viscous glass liquid and carefully breaking and removing the pot once the glass had cooled. Glass pipes came into use around the turn of the first millennium. In Antiquity and even as late as in the Middle Ages objects of glass were luxury articles. Expensive windows which depicted religious themes in a mysterious array of transparent colour adorned churches – but not private houses. It wasn't until the Renaissance that glass came into widespread use in upper class town dwellings, featured in bull's-eye window panes and drinking receptacles which replaced metal tankards.

Germanic tribes used the word *glasa* for transparent or shimmering – which is why it was also used to designate amber, then pop-

ular as jewellery. The main component of what we today call glass is not fossil resin but quartz. Quartz sand – the glass former – melts at ca. 1,600°C with a flux agent (such as soda or potash), which reduces the melting point, and lime which stabilises the cooled product. On cooling the red-hot mass doesn't form crystals as metal does but remains an amorphous solid. It can be blown at around 1,200°C and formed by spinning or pressing it at even lower temperatures. Metal additives effect its colouring, with cobalt turning the glass deep blue, copper making it blue or ruby red and iron oxide changing it to green.

THE SECRET OF MANUFACTURE

The secret behind the manufacture of ruby glass is the subject of Werner Herzog's 1976 film *Herz aus Glas* (Heart of Glass) which is set in the 19th century in a little hamlet in the Bavarian Forest, modelled on the real village of Frauenau. The existence of the local populace is threatened when the chief worker at the glassworks suddenly dies, taking the secret formula for ruby glass with him to his grave. The origins of the glass industry in the forests of Bavaria, Upper Palatinate and Bohemia date back to c. 1000 AD. Glass manufacturers were blessed with an abundance of quartz which was easy to mine and also dense forest with which to fuel their furnaces. Once all the available wood had been used up, the glassworks were moved to a new location. Sites only began to take on a sense of permanence with the dawn of the industrial age and the setting up of new transport networks.

The high iron content of local quartz sand was one reason for green glass being the main product of the Bavarian Forest, named *Waldglas* or forest glass after its colour and place of fabrication. If we consider that the glassmakers of Venice were not even allowed to leave the city, it is understandable that the ingredients and processes which went into the manufacture of unusual glass in East Bavaria were also kept a strict secret – as Herzog's film illustrates.

Relatively early on different regions began specialising in different types of glass. Between Waidhaus in Upper Palatinate and Furth im Wald glassworks primarily constructed flat glass. The sheets were planed and polished in special grinders. They were then transported to Nuremberg/Fürth where they were first vapour-plated with mercury

and by the end of the 19th century with silver to make mirrors. The more southerly operations in the Bavarian Forest concentrated on crystal glass, with the area around Zwiesel becoming known as the *Gläserner Winkel* or glass corner. At the World Exposition of 1900 in Paris the fascinating *Jugendstil* or Art Nouveau glasses of one Ferdinand von Poschinger in Buchenau won a medal.

Names such as Schott and Rodenstock have become market leaders in the development and processing of industrial glass. The international studio glass movement of the 1960s and 1970s gained much of its impetus from the Eisch-Hütte in Frauenau, where Gretl and Erwin Eisch have credited glass with a new artistic value, a far cry from the sobriety of the functional receptacle. Beautifully shaped glass still has its place in everyday use despite the advance of modern plastics. And neither industry or technology can do without this flexible working material, the processing of which has been taught at the technical glass college in Zwiesel since 1904.

Photos, right:
For hikers to the Großer Arber the path to the top is probably more exciting than the summit itself, crowded as it is with tourists, radio masts and the machinery of the cable car. The view is well worth it, though, with the German-Czech border and even the Alps clearly visible on a fine day.

Below:
Southeast of the Großer Arber the waters of the Großer Arbersee shimmer a wonderful bluey-green. One of the botanical anomalies here are the patches of grass which swim on the surface like miniature islands.

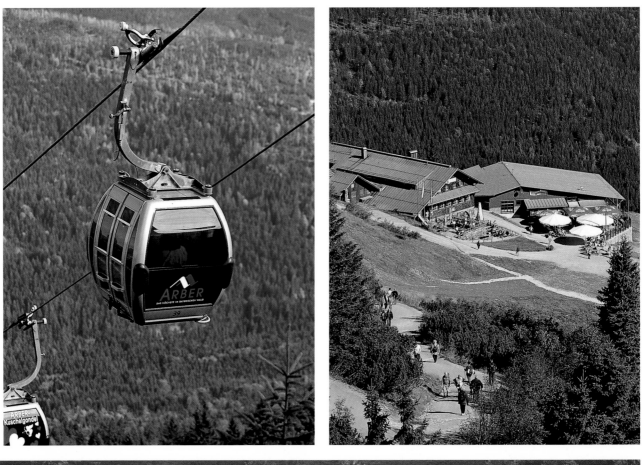

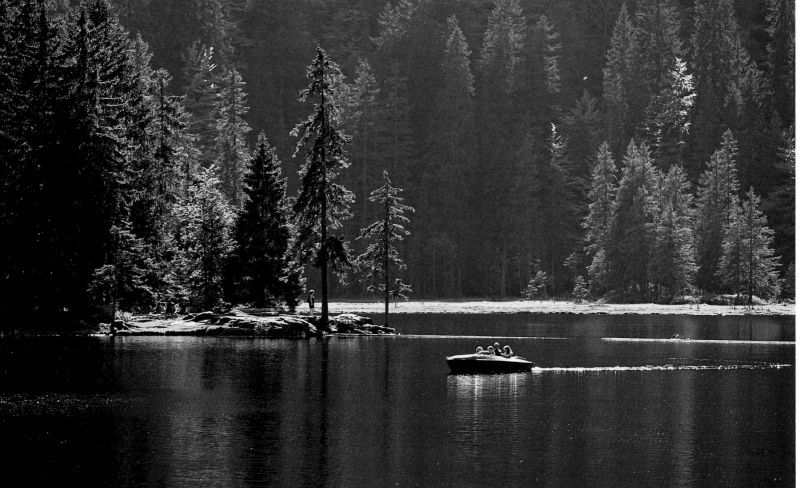

The Zwieseler Hütte (above) clings to the rocks just below the summit of the Großer Arber (left). Self-catering holidaymakers can enjoy modern facilities here in both summer and winter– and absolute peace and quiet once the cable car has shut down for the night.

Right:
The Bayerisches Localbahnmuseum in Bayerisch Eisenstein documents a piece of local railway history. The rail museum has been set up in an old engine shed erected in 1877 by the rather long-winded Royal Privileged Public Limited Company of the Bavarian Eastern Railway.

Below:
The Bayerischer Wald museum village near Tittling is fun for all the family! The 150 buildings, where craftsmen work and animals live, provide a lively insight into the many facets of farming culture in the Bavarian Forest.

Left:
Wood was all important to the people of the Bavarian Forest, both as fuel and as their livelihood. The open-air museum of Finsterau illustrates the great skill which went into the building of the region's typical wooden chalets.

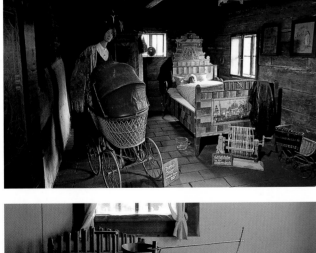

Far left and left:
The farmhouse bedrooms and living rooms at the museums in Lindberg (far left) and Finsterau (left) have been reconstructed with great care and attention to detail. Many of the exhibits spent years gathering dust in attics and had to be painstakingly restored.

Left and far left:
In the authentic setting of the Museumsdorf Bayerischer Wald outside Tittling craftswomen show how fabric used to be printed and sewn and lace made.

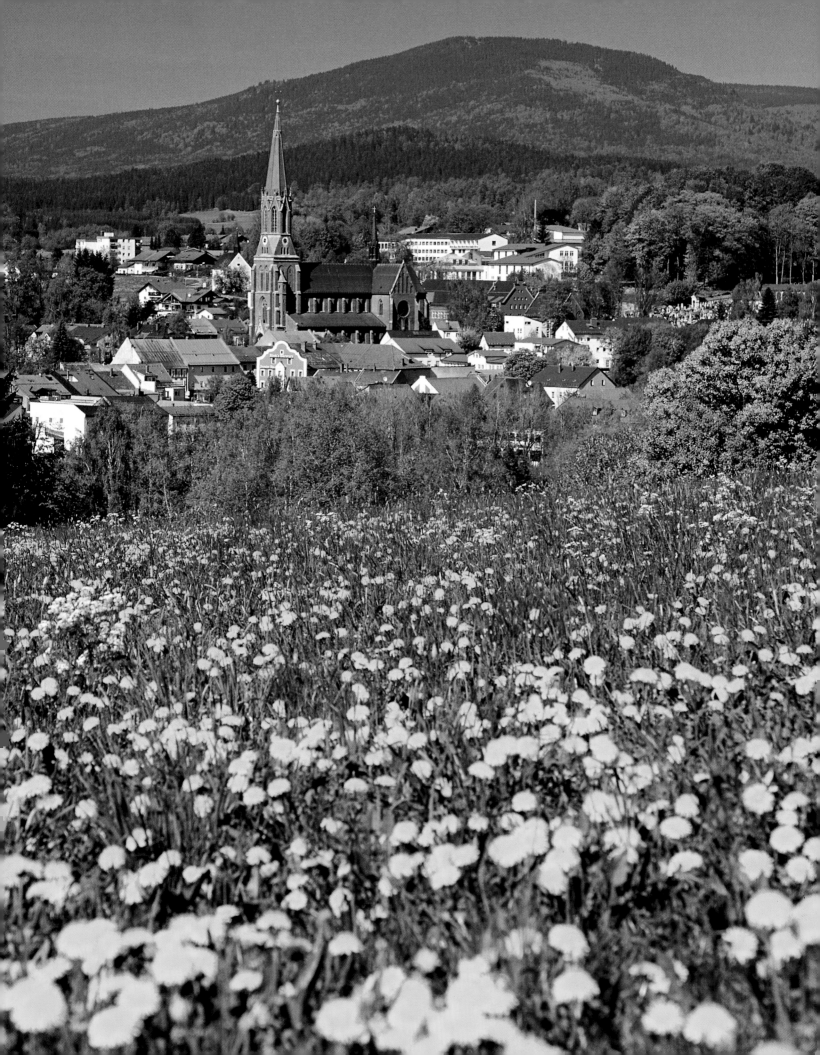

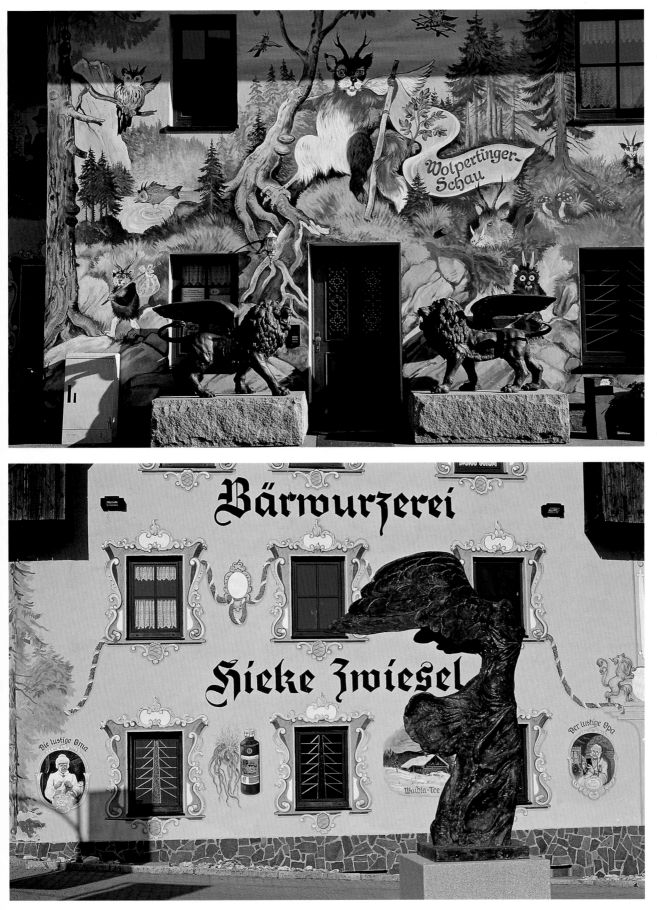

Left page:
The capital of the glassmaking industry in the Bavarian Forest has to be Zwiesel at the confluence of the Kleiner and Großer Regen. Men in search of something very different – gold – actually founded the town; glass began to hold an increasing significance for Zwiesel in the 15th century. Many of its glassworks and workshops are now open to the public.

Schnapps has a long tradition in the Bavarian Forest. Fruit from both the garden and the wild are popular ingredients as are the roots of wild flowers, such as spignel (Meum athamanticum). This plant with its white bracts thrives at altitudes of over 1,000 m (3,280 ft). The Hieke distillery in Zwiesel not only demonstrates how schnapps is made from spignel but also outlines the mystery of the Woipertinger (top), one of Bavaria's many fabled beings.

Page 110/111:
From the 12th-century ruins of Burg Weißenstein you can gaze out over Regen and the Großer Falkenstein (1,312 m/4,305 ft). "Weißenstein" or white stone is a reference to the vein of quartz which runs through the middle of the Bavarian Forest.

Right:
Walking up to the peak of the Großer Rachel you can watch the vegetation change from beech forest to mixed woodland to conifers. At 1,453 m (4,767 ft) the summit is above the natural line of the forest. Just below it is the Waldschmidthaus where you can enjoy some hearty Bavarian fare before making your descent.

Below:
The Rachelsee twinkles invitingly on the hike up from the Rachel-diensthütte to the top of Großer Rachel Mountain.

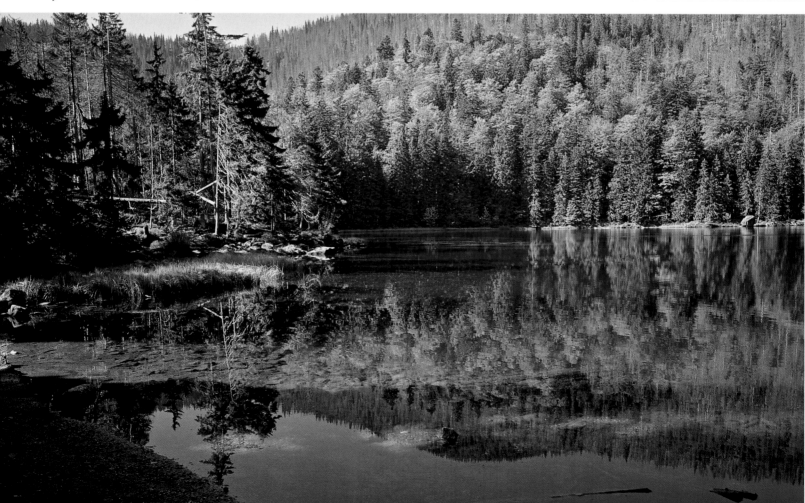

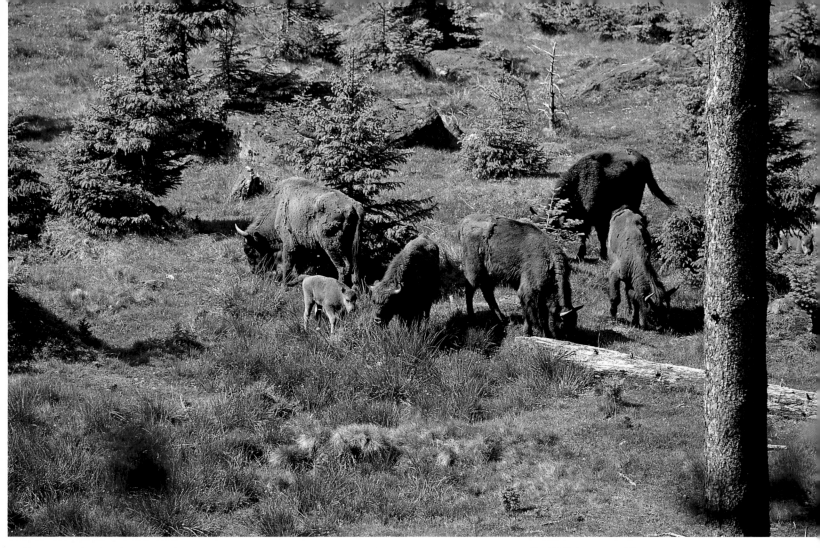

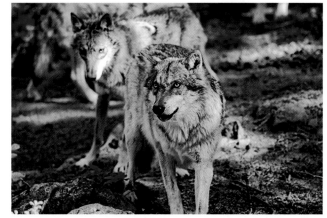

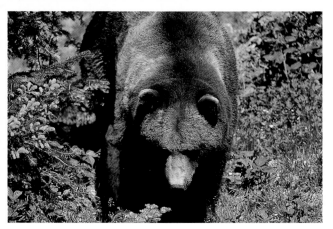

When in 1970 the Bavarian Forest National Park was opened the object of the exercise was not only to preserve the vegetation in one of the oldest mountain ranges in the world but also to reintroduce native species of animal and save those threatened by extinction. Although the proximity of built-up areas somewhat limited the scale of the project, bison, lynx, wolves, bears, capercaillie and black grouse can now be seen here.

Top left:
From the tip of the
Kleiner Falkenstein
1,190 m (3,904 ft) above
sea level there are views
of the Zwieseler Winkel
and the Großer Arber in
the northwest.

Centre left:
The Wackelstein
von Solla near
Thurmansbang in
the southeast of the
Bavarian Forest is
proof of how granite

can weather once its
cover of earth has been
washed away. This
colossus can be rocked or
"wobbled" (as the name
"Wackelstein" suggests)
by a single person.

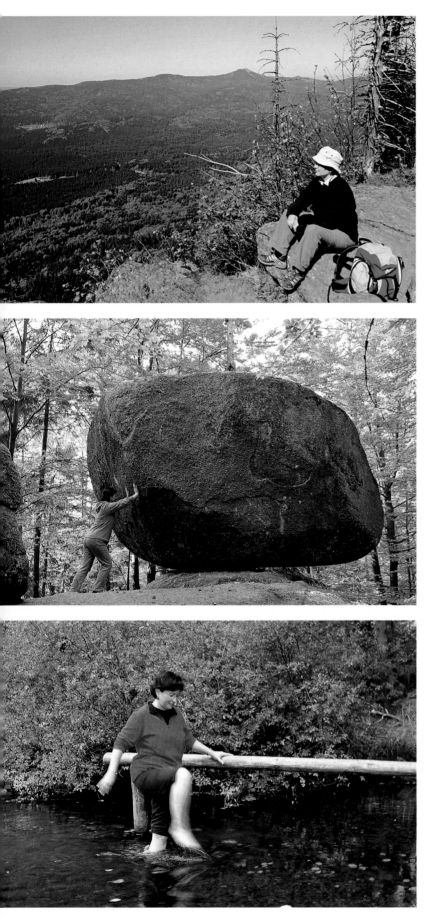

114

Bottom left:
*The community of
Spiegelau in the
Bavarian Forest National
Park boasts a natural
Kneipp pool where weary
hikers can rejuvenate
their tired limbs.*

Below:
*St Oswald is another
place where the founda-
tion of a monastery
prompted the evolution
of an entire village. The
hamlet enjoys an idyllic
setting not far from
the highland moor of
Klosterfilz, its boggy
terrain accessible via
specially-constructed
wooden walkways.*

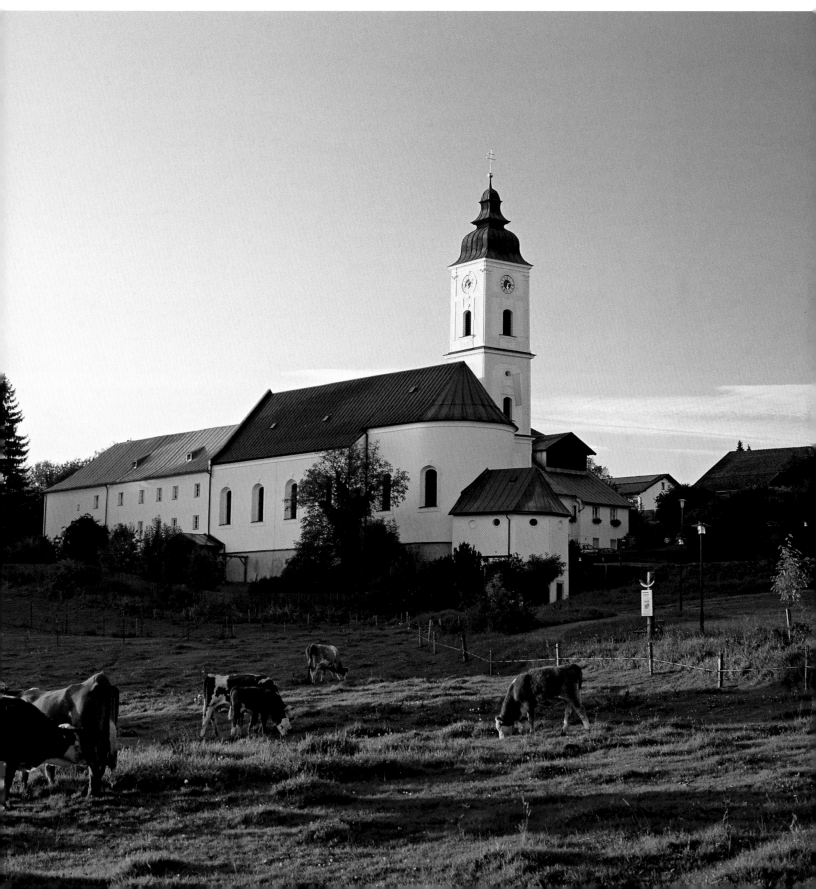

The first feng shui spa gardens in Germany opened in Lalling in 2006. The centrepiece of the park is a lake in a figure of eight, fed by a natural spring. The shape represents yin and yang, the male and female in the 7,000-year-old Asiatic teachings of the unity of opposites. An enormous boulder marks the spot where the positive energy is at its strongest.

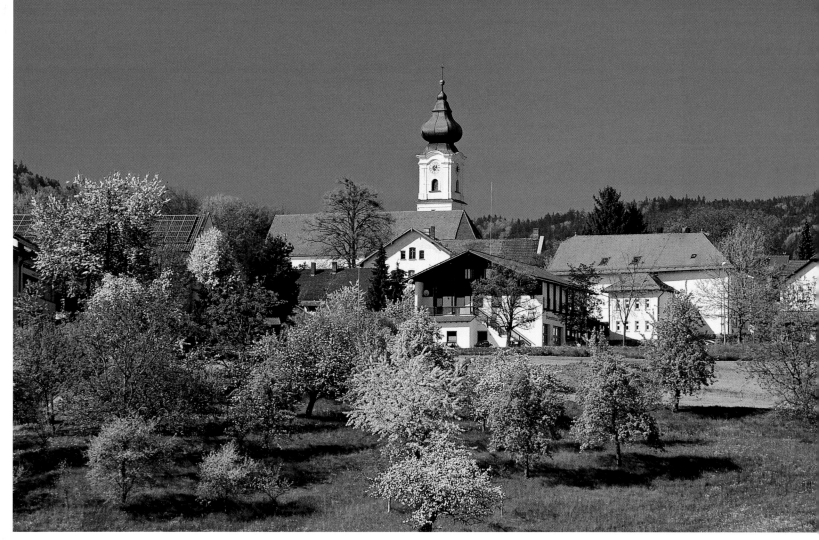

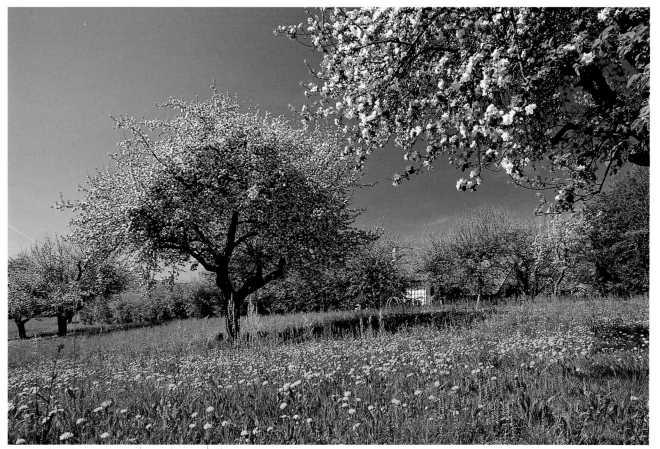

Above:
*Lalling is surrounded
by rolling hills on three
sides. The parish church
of St Stephanus, built
in 1722/23, is visible
for miles.*

Left:
*Lallinger Winkel is also
known as the orchard of
the Bavarian Forest. The
countryside is smothered
in blossom in the spring,
creating a beautiful and
also ecologically valuable
natural habitat which
can be explored in all
its glory at the special
orchard gardens in
Panholling.*

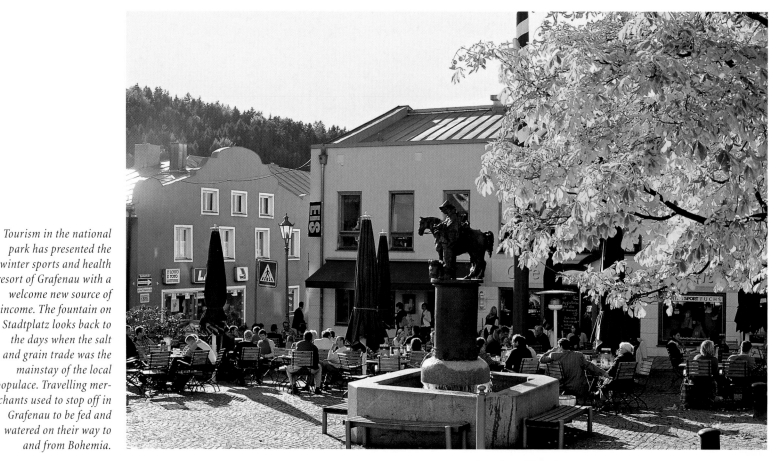

Tourism in the national park has presented the winter sports and health resort of Grafenau with a welcome new source of income. The fountain on Stadtplatz looks back to the days when the salt and grain trade was the mainstay of the local populace. Travelling merchants used to stop off in Grafenau to be fed and watered on their way to and from Bohemia.

The first weekend in August sees the celebration of the Säumerfest in Grafenau. The participants – all in historic dress – set off on the Friday evening with their wagons to spend the night camping in Holz im Wald, eight kilometres (five miles) away. The next day the caravan travels over the Haselberg into Grafenau where the bustling market is already in full swing, complete with musicians, craftsmen and street performers to entertain the crowds.

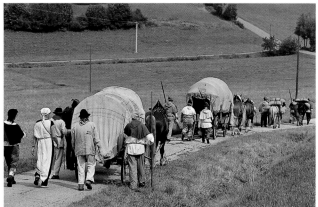

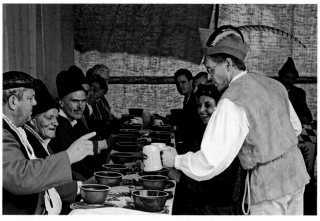

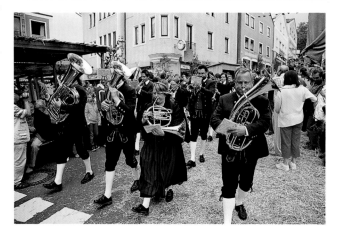

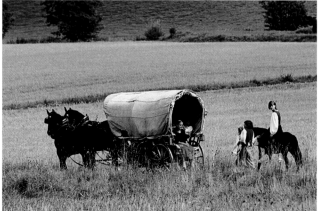

Left:
Fürstenstein (shown here), Saldenburg and Englburg make up the three corners of the hilly Dreiburgenland north of Passau. Historic events in Fürstenstein were closely linked to the fate of its castle which allegedly dates back to the 11th century. The building which now dominates the little town is from the 19th century.

Below:
At the foot of the Kadernberg is the little health resort of Schön-berg, from whence hikers can undertake a number of pleasant forages out into the surrounding countryside.

Right:
Gurgling streams make their idle course through the ancient woodland of the Buchberger Leite between Freyung and Ringelai. The ravine is one of the hundred best natural monuments in Bavaria, its hiking trail just nine kilometres (five miles) long and easy to master with the right footwear.

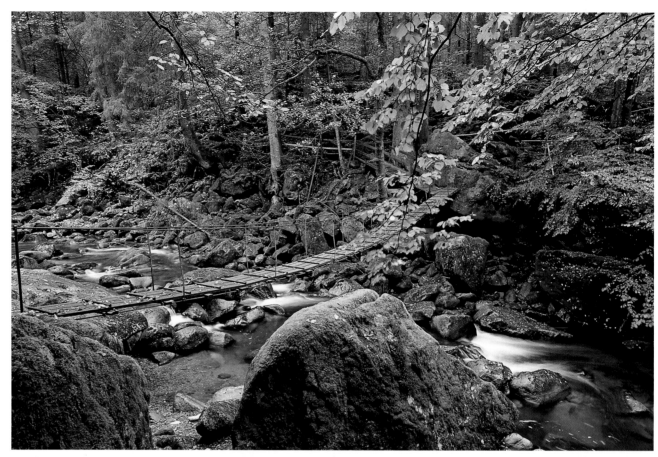

Photos, right page:
In the pocket of land between the Czech Republic, Austria and Germany is the Dreisesselberg, whose highest point is the Hochstein (top, 1,334 m/ 4,377 ft). A cable car sways gently up to the summit from whence visitors have marvellous views out across the green rooftop of Europe. A mountain track along the top of the ridge links the Dreisesselberg with the Plöckenstein, across which the national boundary runs. On the south side of the mountains is a veritable sea of rocks (bottom), formed when granite blocks were split apart by water and ice during periods of glaciation.

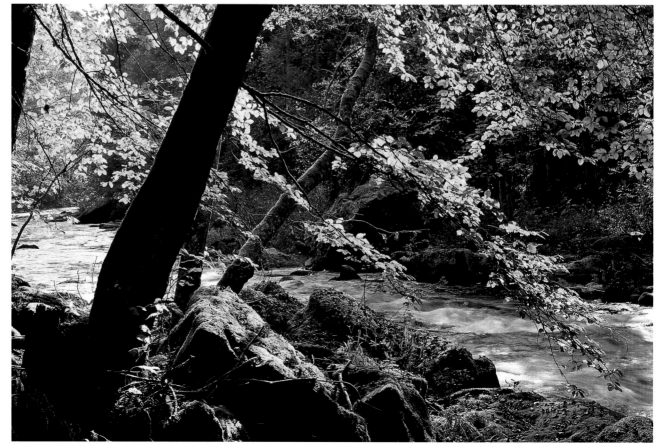

Right:
The Ilztal trail from Ellersdorf/Perlesreut to Passau runs deep through the forest along the mossy banks of the River Ilz, ending where the Ilz flows into the Danube.

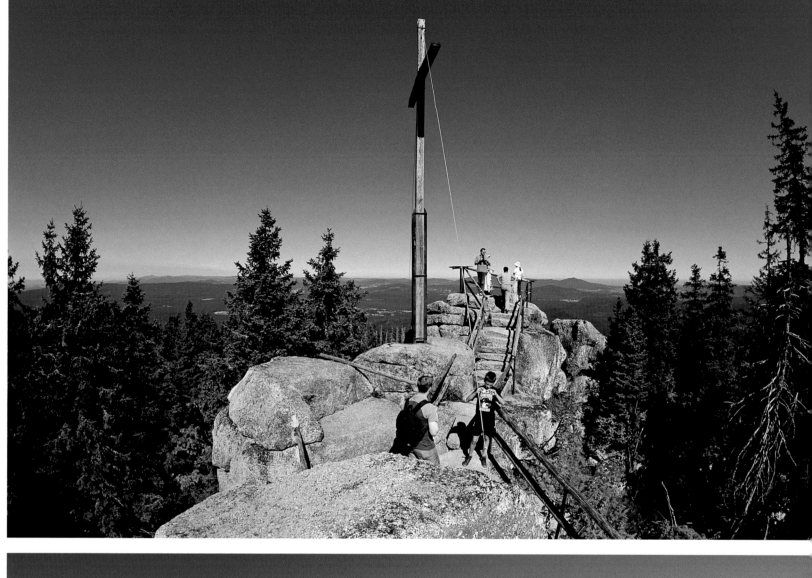
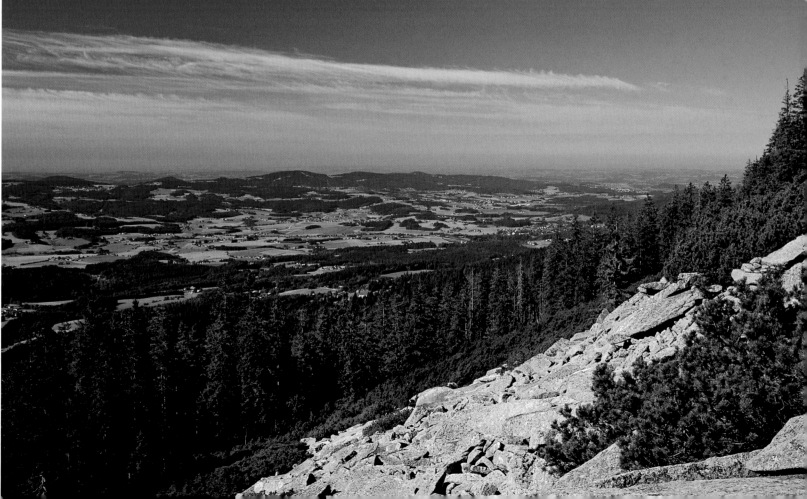

I N D E X

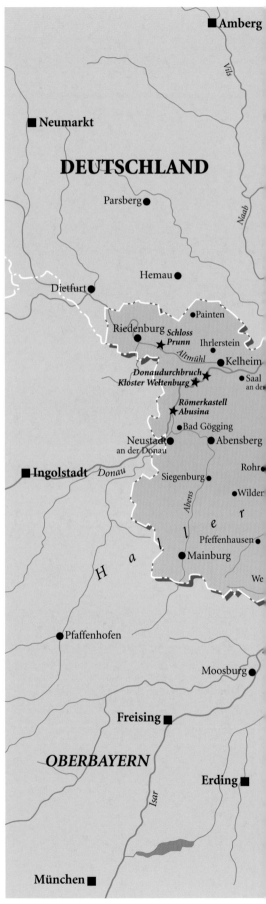

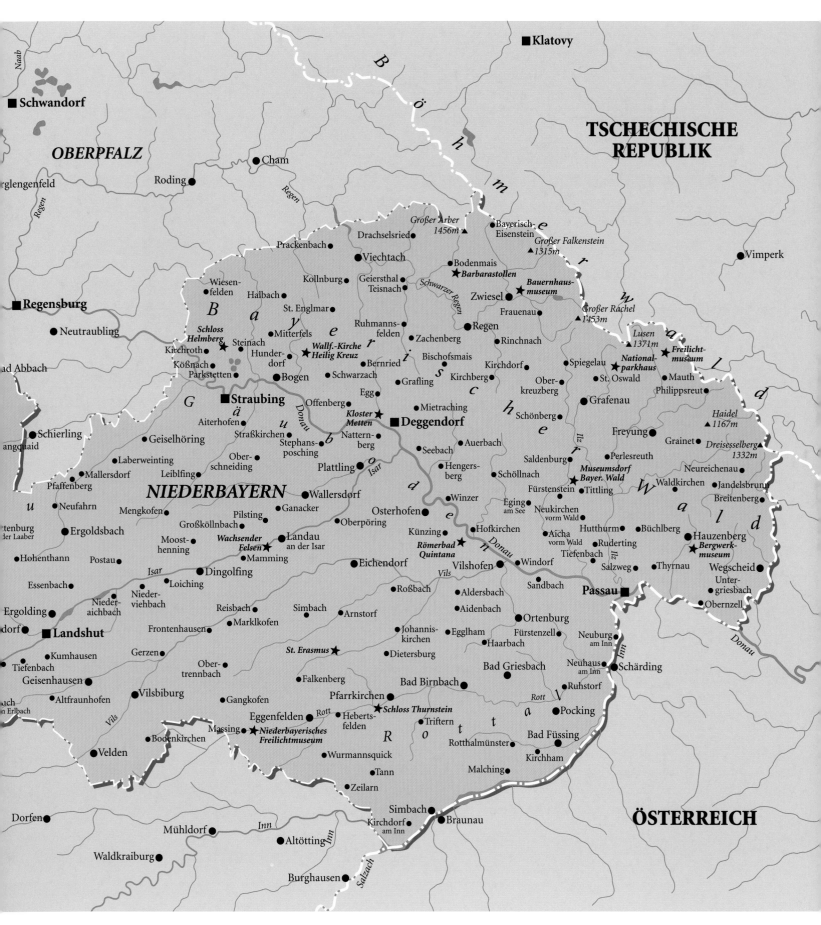

Klatovy

TSCHECHISCHE REPUBLIK

Naab

Schwandorf

OBERPFALZ

rglengenfeld

Roding

Cham

Regen

Regen

Regensburg

Neutraubling

Wiesen-
felden

B

Halbach

St. Englmar

Prackenbach

Viechtach

Kollnburg

Geiersthal
Teisnach

*Großer Arber
1456m*

Bayerisch-
Eisenstein

*Großer Falkenstein
1315m*

Vimperk

a

y

Mitterfels

e

Ruhmanns-
felden

Schwarzer Regen

★ *Barbarastollen*

Drachselsried

Bodenmais

Zwiesel

★ *Bauernhaus-
museum*

r

w

*Großer Rachel
1453m*

**Schloss
Helmberg**

Kirchroth

Steinach

★ *Wallf.-Kirche
Heilig Kreuz*

Hunder-
dorf

Bernried

Zachenberg

Frauenau

*Lusen
1371m*

★ *Freilicht-
museum*

Kößnach

Schwarzach

Bischofsmais

Regen

Rinchnach

Spiegelau

*National-
parkhaus*

a

ad Abbach

Parkstetten

Bogen

Grafling

Kirchberg

Kirchdorf

Ober-
kreuzberg

St. Oswald

Mauth

i

Egg

s

Grafenau

Philippsreut

l

Straubing

G

Offenberg

Mietraching

Schönberg

*Haidel
1167m*

d

ä

Aiterhofen

Straßkirchen

★ *Kloster
Metten*

Deggendorf

c

h

Freyung

Grainet

*Dreisesselberg
1332m*

Schierling

Donau

Nattern-
berg

Seebach

Auerbach

Saldenburg

Perlesreuth

angquaid

Geiselhöring

Stephans-
posching

b

Hengers-
berg

Schöllnach

Fürstenstein

★ *Museumsdorf
Bayer. Wald*

Neureichenau

Laberweinting

Ober-
schneiding

Plattling

Isar

Winzer

Eging
am See

W

Waldkirchen

Jandelsbrunn

Mallersdorf

Leiblfling

o

Neukirchen
vorm Wald

Hutthurm

Tittling

Breitenberg

Pfaffenberg

NIEDERBAYERN

Wallersdorf

d

Osterhofen

Hofkirchen

Aicha
vorm Wald

Ruderting

Büchlberg

a

Hauzenberg

u

Neufahrn

Mengkofen

Pilsting

Ganacker

Oberpöring

Künzing

e

Tiefenbach

Salzweg

★ *Bergwerk-
museum*

l

tenburg
der Laaber

Ergoldsbach

Großköllnbach

★ *Römerbad
Quintana*

Vilshofen

Donau

Windorf

Thyrnau

Wegscheid

d

Hohenthann

Moost-
henning

★ *Wachsender
Felsen*

Landau
an der Isar

Eichendorf

m

Sandbach

Unter-
griesbach

Postau

Mamming

Vils

Aldersbach

Passau

Essenbach

Isar

Dingolfing

Loiching

Roßbach

Aidenbach

Ortenburg

Obernzell

Nieder-
aichbach

Nieder-
viehbach

Reisbach

Simbach

Arnstorf

Fürstenzell

Neuburg
am Inn

Donau

Ergolding

Frontenhausen

Marklkofen

Johannis-
kirchen

Egglham

Haarbach

Neuhaus
am Inn

dorf

Landshut

Kumhausen

Gerzen

Ober-
trennbach

★ *St. Erasmus*

Dietersburg

Bad Griesbach

Schärding

Inn

Tiefenbach

Falkenberg

Bad Birnbach

Rott

Ruhstorf

V

Geisenhausen

Vilsbiburg

Pfarrkirchen

Hebarts-
felden

★ *Schloss Thurnstein*

Triftern

a

Pocking

Altfraunhofen

Gangkofen

Rott

Bad Füssing

ach
n Erlbach

Vils

Eggenfelden

Massing

★ *Niederbayerisches
Freilichtmuseum*

R

o

Rotthalmünster

Kirchham

t

Bodenkirchen

Wurmannsquick

t

Malching

Velden

Tann

Zeilarn

Dorfen

Mühldorf

Inn

Simbach

ÖSTERREICH

Altötting

Inn

Kirchdorf
am Inn

Braunau

Waldkraiburg

Burghausen

Salzach

123

One of the highlights of the Lower Bavarian calendar is the 11-day Gäubodenfest in Straubing which attracts ca. 1.2 million visitors every August.

Credits

Design
hoyerdesign grafik gmbh, Freiburg

Map
Fischer Kartografie, Aichach

Translation
Ruth Chitty, Stromberg
www.rapid-com.de

Printed in Germany
Repro by Artilitho, Trento-Lavis, Italy
Printed/Bound by Offizin Andersen Nexö, Leipzig
© 2008 Verlagshaus Würzburg GmbH & Co. KG
© Photos: Martin Siepmann
© Text: Trudie Trox

ISBN: 978-3-8003-1793-6

Details of our programme can be found at
www.verlagshaus.com

Photographer
Martin Siepmann is a freelance photographer. He has had his work published in numerous books on regional and international travel and also in magazine reports and calendars.

Author
Trudie Trox has been working as a freelance travel journalist for via-Redaktion in Munich since 1999. Prior to this she was a member of the Polyglott travel editing staff for almost two decades.

Picture Credits
All photos by Martin Siepmann except
p. 47 centre © analiza/fotolia,
p. 47 bottom © Michael Röhrich/fotolia.